IMAGES
of America

ATHENS, SAYRE,
AND
WAVERLY

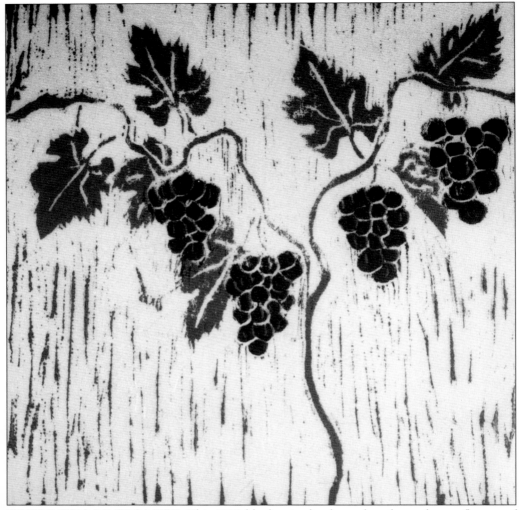

WHERE TWO RIVERS MEET. This 1990 block print by the author shows the confluence of the Chemung and the Susquehanna Rivers as a grapevine and symbolizes the valley as a whole, united community. (Courtesy of the Guthrie Medical Alliance.)

IMAGES
of America

ATHENS, SAYRE,
AND
WAVERLY

Bonnie Stacy

ARCADIA

First published 1996
Reprinted 2004

Published by Arcadia Publishing,
Charleston SC, Chicago IL, Portsmouth NH, San Francisco CA

Printed in Great Britain

Library of Congress Catalog Card Number: 2004116187

For all general information, contact Arcadia Publishing:
Telephone 843-853-2070
Fax 843-853-0044
E-mail sales@arcadiapublishing.com
For customer service and orders:
Toll-free 1-888-313-2665

Visit us on the Internet at www.arcadiapublishing.com

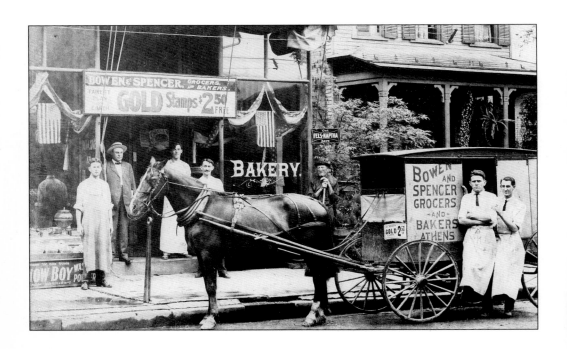

Contents

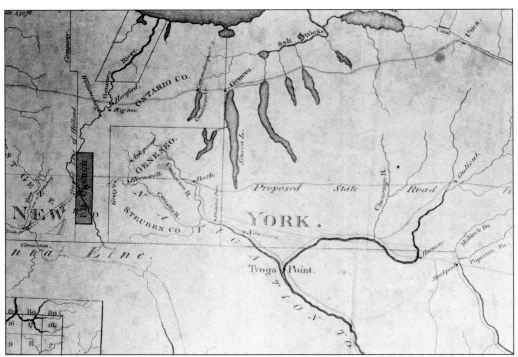

A DETAIL OF AN 1803 MAP SHOWING TIOGA POINT. Tioga Point was an important landmark at the time this map was drawn. Waverly and Sayre did not yet exist, and the name "Athens" was not used for the settled area on the point.

Introduction

This is a book of images that reflect the past of the area where the Chemung and the Susquehanna Rivers flow together. Several municipalities are included in this scope, including not just Athens, Sayre, and Waverly, but South Waverly and Athens Township. Other villages or named enclaves that fall within this area are Milltown, Wildwood, East Athens, and Greens-Landing. Each of these spots has its own history, but they are all tied together by the rivers, and the people around here refer to the area as "the Valley."

It is customary to divide the Valley into its municipalities and examine them separately, but since this has already been done elsewhere, this book is organized differently. The photographs are placed in a rough (very rough) chronological order, either by the date of the subject or by the date the picture was taken. In this way we can see what our forebears saw when they moved from one town to the next at any given time after they settled the Valley. This set-up presents some problems, the most obvious being that photography was only invented in 1839, whereas the Valley was settled much earlier. Painted portraits, pictures of buildings constructed before 1839 but photographed somewhat later, and panoramas of the area serve to illustrate this time. Another difficulty is that some areas are under-represented. We have done our best to include the whole region, but stop short of apologizing for excluding photographs that we do not have access to, or that do not exist.

The Tioga Point Museum has in its collection a wonderful album of photographs of area houses taken in the 1920s and 1930s by M. Louis Gore. Mr. Gore was a photographer, a painter, and an amateur archaeologist. His paintings adorn the Athens branch of Citizens and Northern Bank. Many of the photographs in the museum's album are reproduced in this book. Mr. Gore limited himself to pictures of houses that were already old in the 1920s and '30s, so quite a few of the stately homes built in the early part of this century are not represented. Also included in this book are some of Mr. Gore's valuable pictures of the archaeological excavations that were going on in the Valley in the 1930s.

Another photographer with many pictures reproduced in this book is Eugene Lent. Mr. Lent was quite prolific. He worked from the 1920s through the 1950s and a portion of his files ended up in the Tioga Point Museum. Sadly, much of the identifying information about the photographs did not stay with them, but we have been able to reconstruct some of it.

Among the historical sources used are the files and book collections of the museum, as well as oral history from people who have lived in the Valley for a long time. I have borrowed freely from Louise Welles Murray's *Old Tioga Point and Early Athens*, published in 1908, and unattributed quotes may be assumed to be from that source.

Because of the chronological organization, areas that were settled later, such as Sayre, appear further on in the book. In the case of Sayre, this earlier lack of representation is made up for with a wealth of photographs from 1870 on. The most recent time is neglected in favor of historical photographs. We leave it to future historians to record the goings on of 1996. Unless otherwise noted, photographs are in the collection of the Tioga Point Museum.

Acknowledgments

I have received help and photographs from many people. Most of the Waverly photographs and the information that goes along with them come from Don Merrill, who kindly allowed reproduction of many items from his extensive collection. Other Waverly materials were provided by the Waverly Free Library, where Beverly Dann and the rest of the staff were helpful in steering me in the right direction. Many Sayre photographs came from Henry Farley and Molly Caplan, who were generous and accommodating in allowing me access to their collections. Virtually all of the Athens pictures and many of the others are from the collection of the Tioga Point Museum. The museum's board of directors has kindly allowed me to work on this project and use museum materials. Special mention is made of former Tioga Point Museum Director Cynthia Rajala, who organized the museum's photographs, gave advice, and thereby made my life easier. Much of the photographic reproduction was done, gratis, by Ned Margie. Others who helped with individual photographs and/or history are Louise Shallenberger, Destiny Kinal, the staff of the Athens Library, John Thurston, Joann Homan, Jan Beck, Letha Rowe, Ruth Tozer Bixby, Maryann Friend, Chuck Frisbie (and his mom), Helen Kasper, and Joe Wolf.

I thank all of these persons and organizations, without whom this project would never have happened. I also thank anyone who has ever donated a photograph to the Tioga Point Museum; your generosity is deeply appreciated.

Bonnie Stacy
Athens, Pennsylvania
1996

One
Settlement

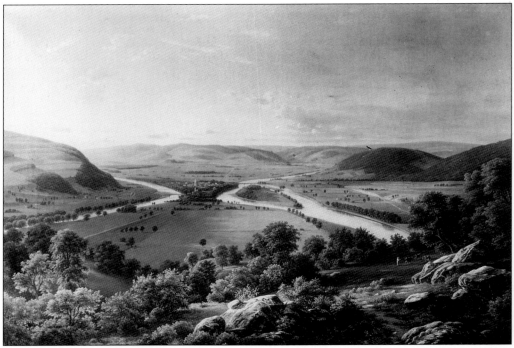

TIOGA POINT (1856). C.F. Welles commissioned Julius O. Montalant to do an oil painting of the Valley early in the career of the artist. He clearly shows the extent of settlement at the time, with special emphasis on the grand house of his patron. Sayre had not yet been founded, but Waverly can be seen as a series of small white dots in the distance.

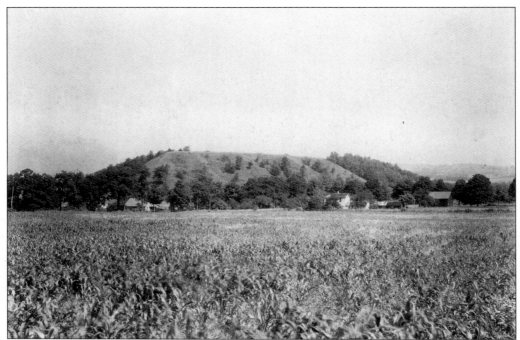

SPANISH HILL. This hill has given rise to many stories and theories of its possible uses in the distant past by the Native Americans who used to occupy this area. Many believe it is the site of Carantouan, the Susquehannock stronghold visited and described by Champlain's scout Etienne Brulé in 1615. Archaeological excavations have turned up nothing to confirm this on the hill itself, but cannot rule out the Valley as a possible, even likely, site of Carantouan.

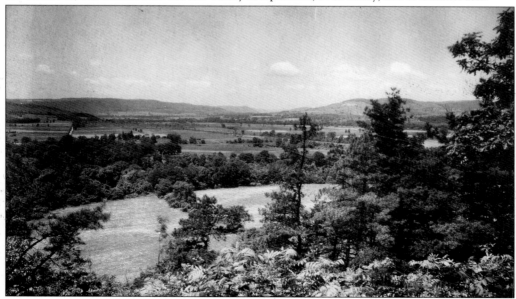

LOOKING NORTH FROM SPANISH HILL (1933). Cleared farmlands and wooded areas can be seen in this view to the northwest, into New York state. The settlement area of Waverly is toward the east, and therefore not visible.

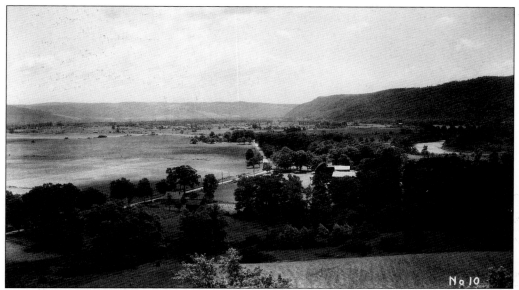

LOOKING SOUTH FROM SPANISH HILL (1933). The Chemung River, with Round Top rising above it, is in the upper right portion of the picture. To the left are the plains of Tioga Point. The rivers meet just south of here. These plains are now filled with houses, roads, and other signs of development.

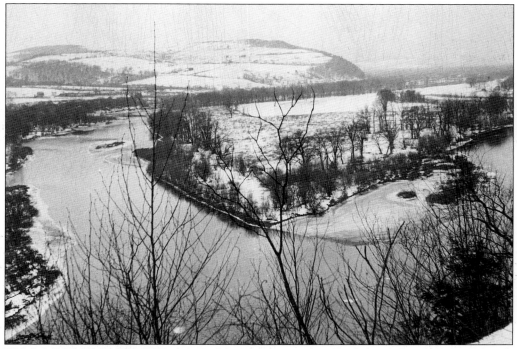

TIOGA POINT IN WINTER (1949–50). Looking north toward the point, the view is much the same today as it was in 1950, 1850, and probably for a very long time into the past. The plain was cleared, occupied, and farmed by prehistoric peoples and continues to be used for the same purpose today.

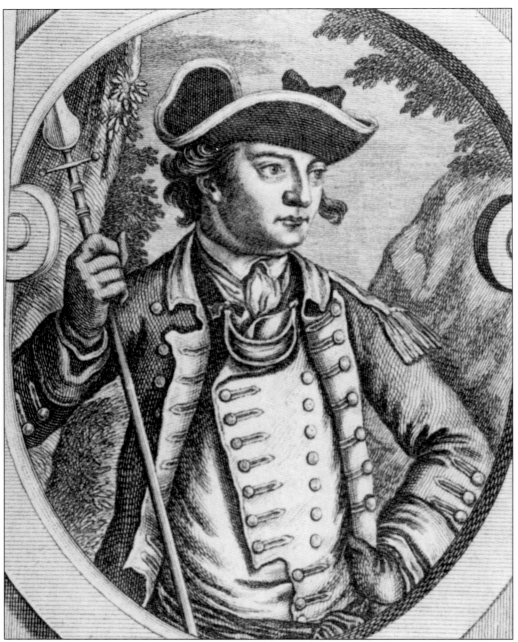

MAJOR GENERAL JOHN SULLIVAN. Tioga Point was an important stop on Sullivan's 1779 march to drive the Iroquois from the area. The point had been occupied by Iroquois and British troops immediately before Sullivan and his troops arrived, but they left as the Continental army approached, so no battle was fought here. Sullivan's army arrived at Tioga Point on August 11, and a fort was built at the spot where the rivers are closest together. General Clinton's forces joined them here on August 22. On August 29 the army fought and won a battle at Newtown with the British and Iroquois. The Americans then dismantled the fort so that it could not be used by the enemy.

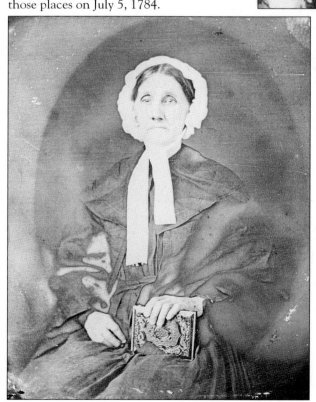

MAJOR ABRAHAM SNELL (RIGHT)
AND MARGARET SNELL (BELOW).
These daguerreotypes were taken when
Major Snell and his wife were elderly, but
he has the distinction of being the first
child born to settlers who came into the
area after the Revolution and remained
permanently. His family lived first at
Sheshequin, then at a site just west of the
Chemung River. He was born at one of
those places on July 5, 1784.

JOHN SHEPARD (1765–1837). Mr. Shepard was one of the most important early settlers of the Valley. He came originally to Sheshequin, clerked for Matthias Hollenback, and then moved to Milltown (now part of Sayre) where he operated the only mill within 50 miles. He purchased extensive tracts of land, including most of what is now Waverly.

MRS. SHEPARD. But which Mrs. Shepard? John Shepard was married twice, first to Anna Gore in 1790. Anna Shepard gave birth to seven children, including Julia, who married George Perkins and wrote *Early Times on the Susquehanna*, the first history of the area. After Anna's death Mr. Shepard married a woman from Long Island, a Miss Hawkins. This photograph of a painted portrait is identified only as "Mrs. Shepard."

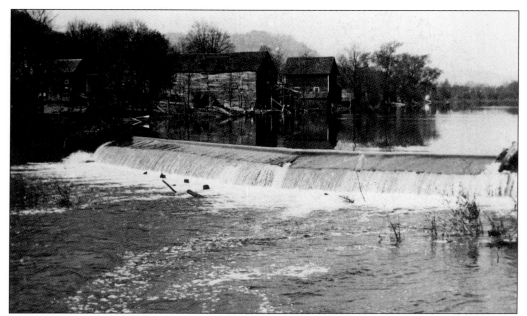

THE CAYUTA (SHEPARD'S) CREEK MILL POND. The mill turned Milltown into a thriving area. In 1815, Doctor Amos Prentice settled here (see p. 48). J.F. Satterlee operated a business in Milltown and married Julia Prentice, Dr. Prentice's daughter. Later Mr. Satterlee moved to East Athens and ran the ferry across the Susquehanna. (Photograph courtesy of Don Merrill.)

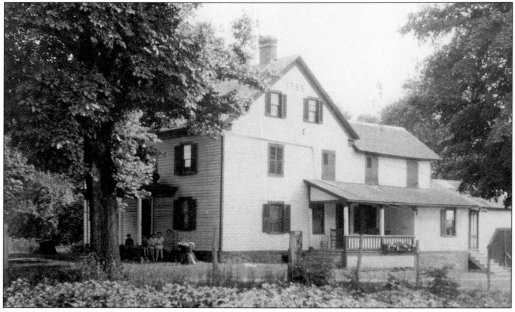

IRA STEPHENS' HOUSE. This house was built in 1795 near Spanish Hill. Ira Stephens was born in Connecticut in 1760 and moved to the Valley in 1788 after serving as an aide to Washington during the Revolution. He was murdered in 1803 in Angelica, New York, but his family remained in the Valley. The house was torn down sometime after the 1920s.

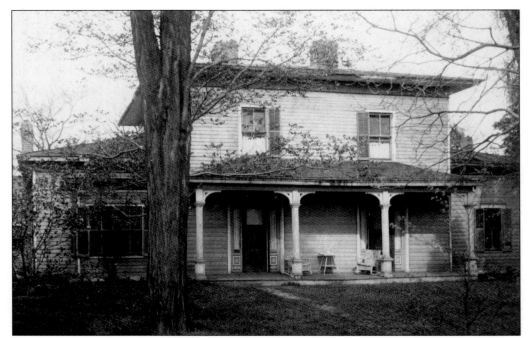

THE JUDGE EDWARD HERRICK HOUSE. This house was built in 1795 by Michael R. Tharp and purchased by Judge Herrick in 1820. Originally it stood by itself on a large piece of land north of the old cemetery in Athens. Now it stands among the houses on Edward Street.

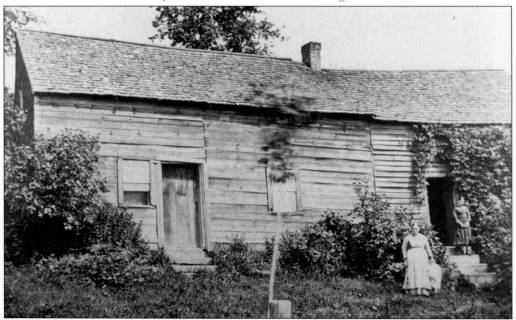

THE HOUSE OF JOSEPH SPALDING. In 1791 Spalding purchased the lot just west of Morley's Crossing and built this house shortly afterwards. He had been a Revolutionary soldier and was one of the original proprietors of the Athens Academy. It can be assumed that the house did not remain standing long after this picture was taken in the late nineteenth century.

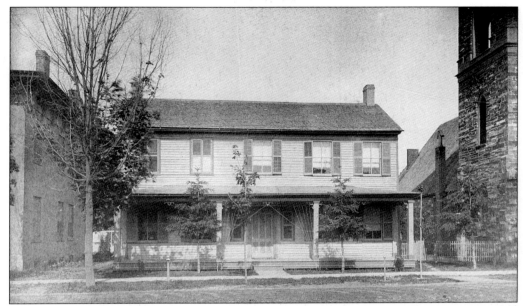

DR. HOPKINS' HOUSE (BUILT 1802). Louise Welles Murray writes, "The most important village happening of this period was the building of Dr. Hopkins' house, the most pretentious in the village . . . The large house torn down but a few years since [in 1902] was only the main body; on each end were large wings which were later detached, moved and converted into separate houses." This house stood on the site just north of the Episcopal church in Athens.

THE OLD SALTMARSH TAVERN. This house still stands on the corner of South Main and Tioga Streets in Athens. It was built by John Saltmarsh in 1801 as a public house. Between the 1890s and 1928 the house lost this porch (not original anyway), gained a couple of dormers, some shingles on the gable ends, and a new porch. Since then it has been converted to a two-family home with yet another porch and two front doors.

THE HOUSE OF EBENEZER BACKUS. Although there is some confusion, it seems that this house was built using one of the wings from Dr. Hopkins' house (see p. 17). The two homes were of similar styles. The Backus family occupied this house for about fifty years and it was torn down in 1901. The house stood on the lot just north of the Patrick House (see p. 22). There is no building on this lot now.

THE MURRAY INN. Built by Abner Murray in 1807 or 1809 and remodeled sixty years later, this house served as a residence and a popular inn for travelers and lumbermen. Originally it had a winding stair to a second-floor ballroom and a shed with a brick oven where lumbermen and canal workers could do their own baking. The house still stands on the west side of the Chemung.

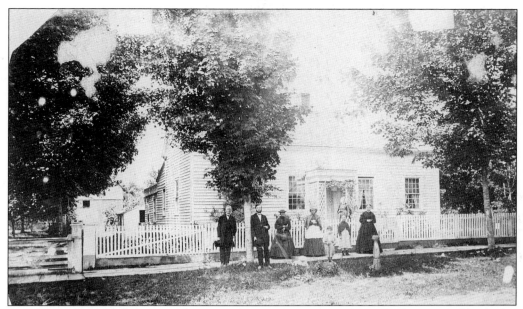

CHESTER PARK'S HOUSE. Chester Park moved to Athens from Sheshequin and built this house on South Elmira Street around 1835. Mr. Park was a prominent member of the Methodist church. This photograph was taken about 1866 and shows family members Chester, David, and Myra Park; Rebecca Huston; and Herbert, Jennie, and Harriet Johnson.

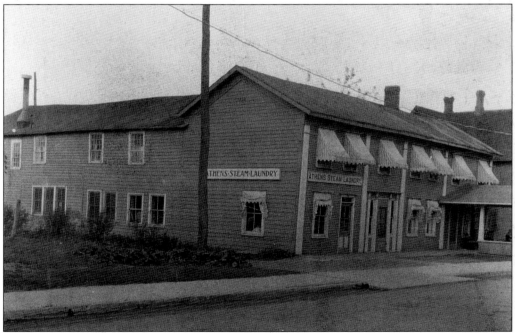

THE "AMERICAN HOUSE." This building was constructed on Susquehanna Street shortly after the first bridge (which replaced a ferry of long-standing operation) was erected. Originally it was a temperance hotel owned by Thomas R. Davies, who was also a justice of the peace. By the 1930s the building was being used as a laundry.

THE TYLER FARMHOUSE. Francis Tyler purchased his farm in 1818. He was ". . . one of the wealthiest and most respected citizens of Athens." The farm was located along Elmira Street in Athens and has long since been divided into building lots.

GUY TOZER'S HOUSE. The photographer, M. Louis Gore, identified this house as having been built by Guy Tozer around 1820. There were two Guy Tozers, "Big Guy" and his son "Little Guy." This is not the more familiar Tozer home that stands on North Main Street. The location of this house is not clear but it may have been on North Elmira Street. In the 1920s it was a place to buy lumber.

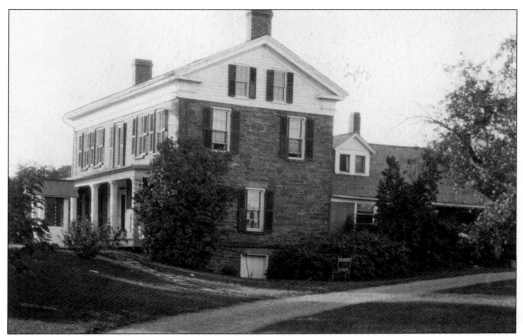

THE MURRAY HOUSE. The first part of this South Waverly house was built in 1826. The front, stone part was added in 1855 by Harris Murray, grandson of one of the original settlers of the area. The house was occupied by generations of Murrays.

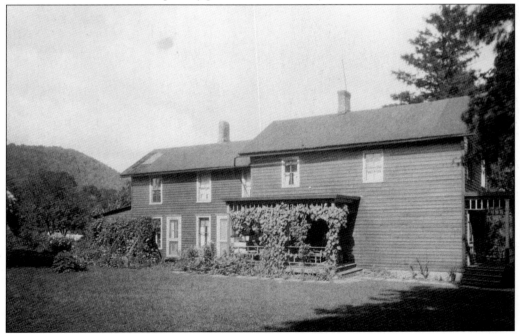

THE HAT FACTORY. Thomas I. Brooks built this structure on South Main Street in Athens in 1827. Originally it was a hat factory, but it spent most of its existence as a residence. By 1988 the building was unsound. It was demolished and has been replaced with a new house.

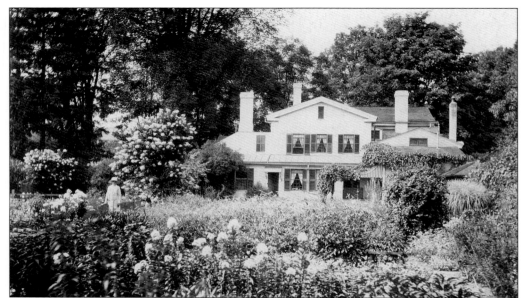

THE BACKYARD GARDEN OF 721 SOUTH MAIN STREET, ATHENS. This house was built by Harris W. Patrick after he arrived in Athens in 1836. Later it was occupied by Mrs. E.H. Perkins, who is probably the lady standing between the phlox and the hydrangea in this photograph.

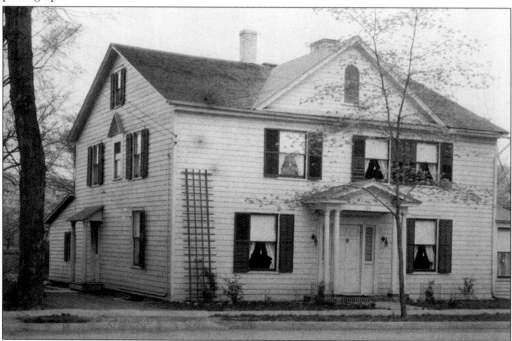

GEORGE PERKINS' HOUSE. Around 1827 Perkins built this house on South Main Street for use as a pharmacy, as well as a home for himself and his wife Julia. After the Fugitive Slave Act was passed in 1850, Perkins, an ardent abolitionist, constructed a secret hiding place in the cellar and this house became a station on the Underground Railroad.

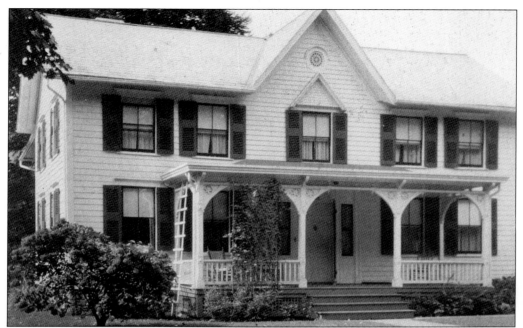

THE HOUSE AT 632 SOUTH MAIN STREET, ATHENS. Nathaniel Clapp Jr. built this house, which originally looked more as it does today than it did when this picture was taken in the 1920s. The front gable and porch were added after 1910 and removed some time later, making it difficult to identify the house from this photograph.

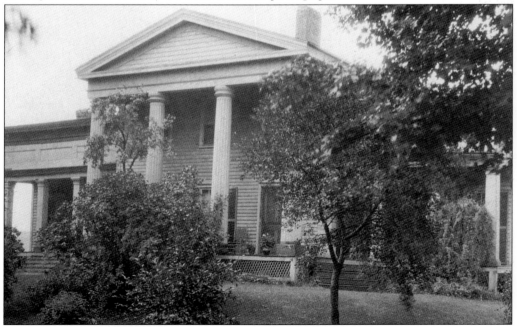

THE PITNEY SNYDER HOUSE. This fine Greek Revival house originally stood on a large piece of land in South Waverly on Elmira Street. It was built by William Pitney Snyder in 1842 and demolished in 1970 to make room for the Route 220 bypass.

SIDNEY HAYDEN (1813–1890). Mr. Hayden and his wife Florilla were born in Connecticut and came to the Valley in 1840. He purchased a large piece of land in the area that would become Sayre thirty years later, and proceeded to use the clay on that land to make bricks, and his fortune.

FLORILLA MILLER HAYDEN. The Haydens had six children: Julius, Algernon, Albert (Bert), Charles, Ruth, and Sidney. Florilla died twenty-two years before her husband.

"THE PINES." The Haydens' house was erected in 1840 and constructed of the local brick produced by its builder. For many years, it stood alone in the area between Athens and Waverly. Mr. Hayden was the Sayre postmaster for the last five years of his life and the library of his home was the post office for that time. The Haydens' son Bert lived in the house after his father's death. When Bert died in 1918 the property passed to his older son Paul and then to Paul's widow, Helen, in 1936. By 1964 there were no Hayden family members in Sayre. The building was sold and demolished to make way for the new St. John's Lutheran Church.

THE HOUSE AT 512 SOUTH KEYSTONE AVENUE. Known as the Merrill home, this house was built about 1830–40. It had a succession of owners, including the Pooles, Greys, and Macafees.

THE ELLSWORTH HOUSE. Built in 1840, this house may have been the first in Athens used solely as a residence and not also serving as a store or hotel. Lemuel Ellsworth moved on to Chicago in 1850. Except for the car in the driveway, this house has changed little over the years.

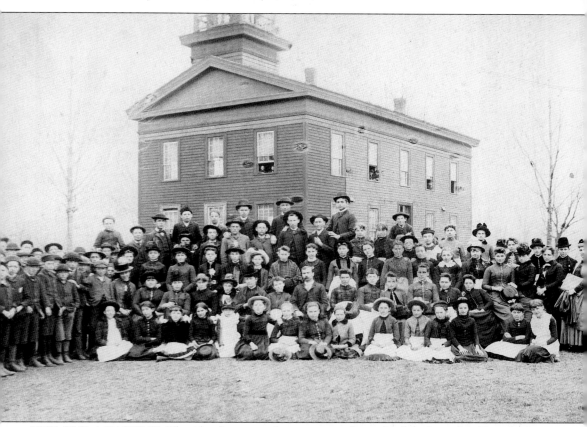

THE OLD ACADEMY. The idea for an academy came early to the founders of Athens, but it was not until 1814 that the school was finally opened. By 1840 the Athens Academy had gained a good reputation and was doing well when, in 1842, the building was completely destroyed by fire. A replacement, with a colonnaded porch, was completed in 1843. In 1868 the school was transferred to the borough, which continued to use the building until a new high school was built. The columns were removed and the porch filled in to add space, as seen in this 1885 photograph, but later the building was restored to its original appearance (with the deceptive date 1797 on the pediment representing the date of the idea for the school rather than the date of construction of the building). It stood on the site until 1925. The most illustrious pupil to attend the Athens Academy was Stephen Foster in 1840–41; he was in Athens to be near his brother, who was working on the canal.

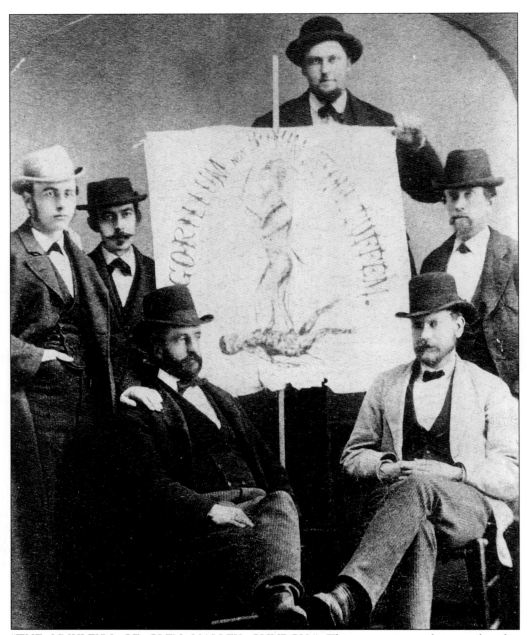

"THE UNKLEYN OF GLEN VALLEY CHURCH." This mysterious photograph of a daguerreotype shows several early Valley inhabitants and is inscribed on the reverse, in old-fashioned and difficult handwriting: "Front, sitting at left, Edmund P. Herrick, Bishop B B; sitting at right, Walter Comstock or Uncle Randum Gun; left standing, Jas. McDonald; Edward Herrick, Uncle Horrible; top George Spaulding; at right standing Guy Tozer, Uncle Tutelo. Unkleyn of Glen Valley Church supporting their banner with the Patriarch Wm. Shepard standing with one foot on the prostrate body of the Gorilla or Prof. Gantrelle [?] a pagan who had gained the enmity of the Unklyn and was passing through purgatory." The banner reads "Gorillum non Bonum Atque Tuffem". . . I think.

Two
Early Growth:
1845-1900

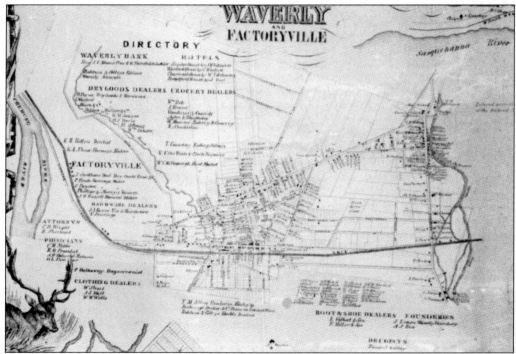

A MAP OF WAVERLY AND FACTORYVILLE (1855). This detail of a large wall map of Tioga County, New York, shows that Waverly was already an active town with many businesses and residents. The town had been incorporated just the year before but the railroad was already there and the village was growing. (Photograph courtesy of Don Merrill.)

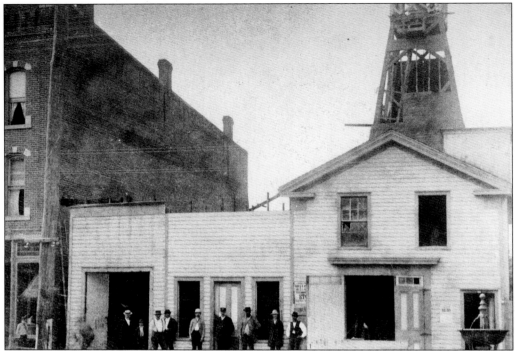

THE WAVERLY FIREHOUSE. Fire-fighting was an early concern of Waverly's residents. In 1855, after a fire destroyed seventeen buildings on Broad Street, a hand engine was purchased and this building was erected to house it. It stood where the village hall is located, in a spot made vacant by the disastrous fire. (Photograph courtesy of Don Merrill.)

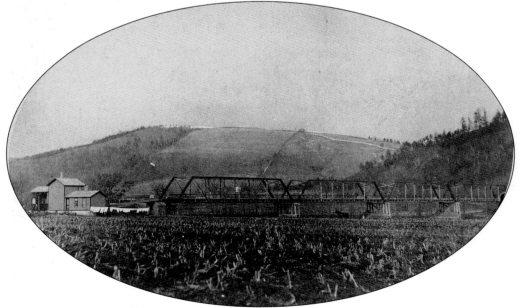

THE WHITE WAGON BRIDGE. This bridge stood west of Waverly and spanned the Chemung. It was washed out in the flood of 1972.

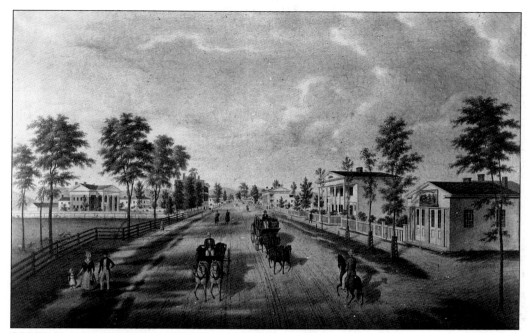

SOUTH MAIN STREET, ATHENS, IN 1846. Henry Walton painted this view of South Main Street in Athens looking south from the old cemetery. Only two buildings pictured are still standing. The house in the center on the right is difficult to recognize because the upper half of the porch has been converted into a room. The brick structure on the left, the Shipman house, has changed little.

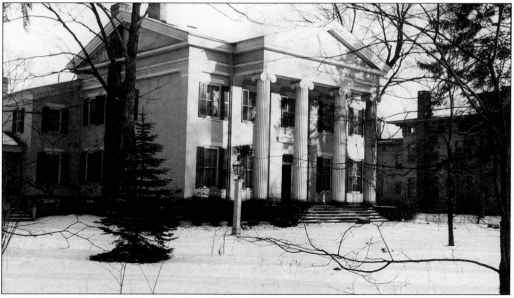

THE SHIPMAN HOUSE. Also known as "Clovercroft," this is one of the most impressive houses on South Main Street. Chauncy Shipman built it in 1841, and after he left Athens in 1859 it was occupied by several families in succession until it was purchased in 1946 by the Athens American Legion. Today it is once again a private home.

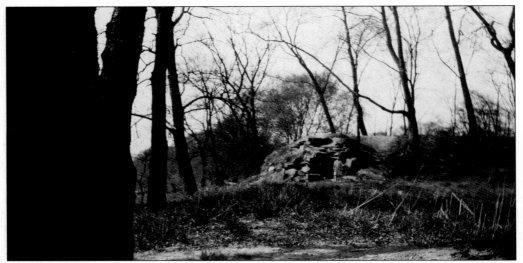

MASONRY OF THE OLD CANAL WHARF. This fragment at the foot of Harris and Chemung Streets in Athens was part of the little that remained of the North Branch Canal in the spring of 1946. The canal was begun in 1830 but not completed until 1856. The railroad superseded it before many years had passed, and the canal fell into disrepair.

THE CANAL OFFICE. This South Main Street home is the former North Branch Canal office. It was built on the southwest corner of Colonel Welles' lot and a private telegraph line, "the first in the area," connected the office with Waverly.

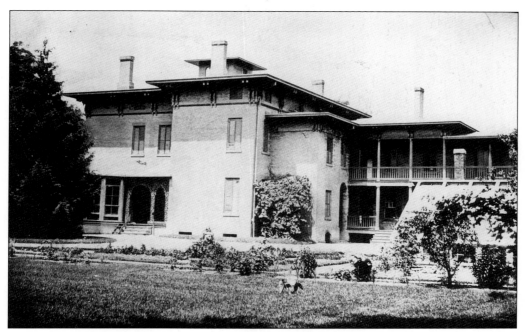

THE HOUSE OF C.F. WELLES JR. One of the enthusiastic canal supporters, who had a large stake in the business, was Colonel C.F. Welles. He was also involved in the building of the water works of Brooklyn, New York, and many railroads. He bought the entire North Branch Canal in 1859 and later sold it to the Lehigh Valley Railroad. He built this elaborate Italianate house, (this is a side view from the south) in 1851.

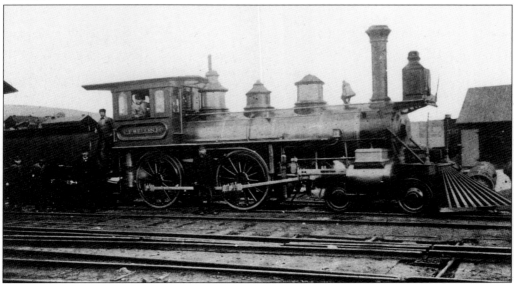

AN EARLY LOCOMOTIVE OF THE PENNSYLVANIA AND NEW YORK RAILROAD COMPANY. Called the C.F. Welles Jr., this engine was built in 1870. It was engine #203, E12 Class, and was rebuilt in Sayre in 1889. Mr. Welles acquired the North Branch Canal to "carry out the great ambition of his life, a railroad along the Susquehanna Valley, which should form a continuous line from Wyoming coal fields to the great lakes."

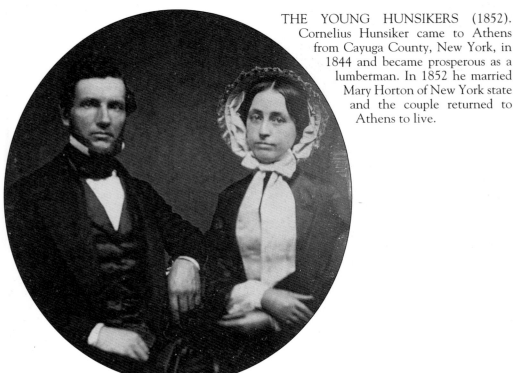

THE YOUNG HUNSIKERS (1852). Cornelius Hunsiker came to Athens from Cayuga County, New York, in 1844 and became prosperous as a lumberman. In 1852 he married Mary Horton of New York state and the couple returned to Athens to live.

THE HUNSIKERS' FIRST HOUSE IN ATHENS. Before his marriage, Mr. Hunsiker purchased this house, which had been left in an unfinished state by its original owner. He completed the building in 1852, adding some Greek details that were popular at the time.

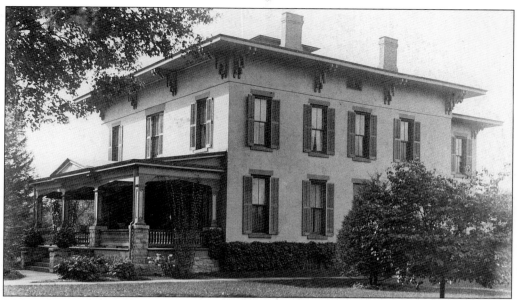

THE HUNSIKERS' SECOND HOUSE IN ATHENS. Some time later the couple moved with their children to this house, built in 1863 by Frederick Page on the site of Hollenback's trading post. Their daughter Mary lived here until her death in 1952 at the age of ninety-six. A memorial tribute states: "Older residents cherish the memory of Miss Hunsiker's summer garden parties in the tea house overlooking the gay flower gardens and the rippling Chemung . . ."

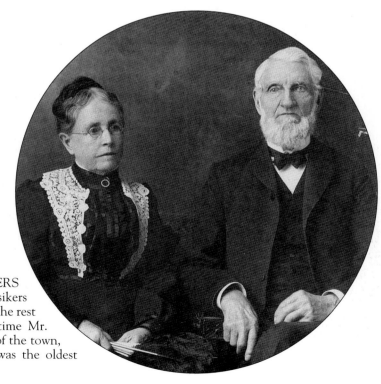

THE OLD HUNSIKERS (1902). The Hunsikers remained in Athens for the rest of their lives. At one time Mr. Hunsiker was a burgess of the town, and when he died he was the oldest resident of Athens.

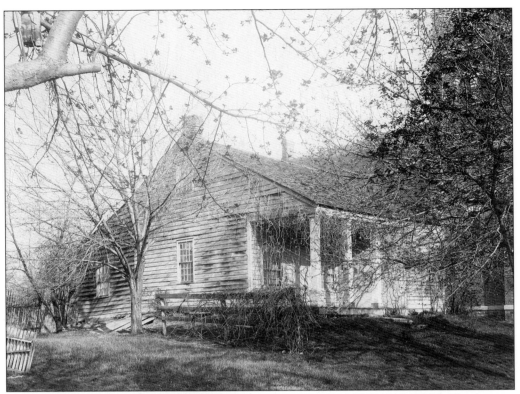

ZEPHON FLOWER'S HOUSE. This house stood on the site of the Methodist church parking lot, just north of Paine Street in Athens. Mr. Flower was the first surveyor of the area and he created the maps and documents that make it possible to understand the complicated land transactions of his time. He was the first of several generations of surveyors, a tradition that ended with Nathan Flower Walker in the middle of this century.

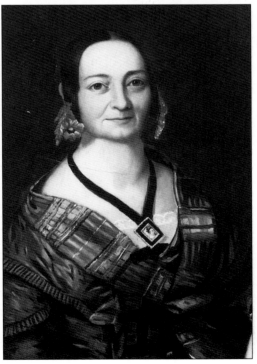

ZULEIMA FLOWER WALKER. This beautiful portrait hangs in the Tioga Point Museum. She is wearing a dress with a colorful collar and has a miniature portrait in a locket around her neck. Mrs. Walker was born in 1801. She was the daughter of Zephon Flower and the mother of Zephon Flower Walker.

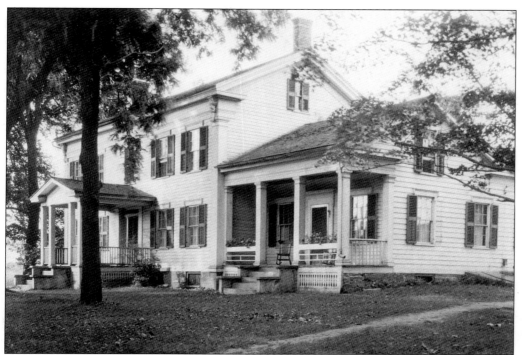

A HOUSE BUILT BY ISAAC BEAKMAN. This house was built in 1848 in South Waverly. The photographer's note says that later it was owned by "Abram and Jacob & sisters," and that when the picture was taken in the 1920s, it was owned by C.M. Bowen.

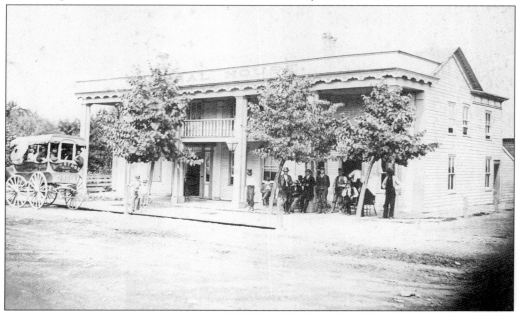

THE CENTRAL HOUSE. The log books from this early Athens hotel show that many people we would consider local spent the night here, a fact that attests to the difficulties of travel in that era. A trip of only a few miles could take hours.

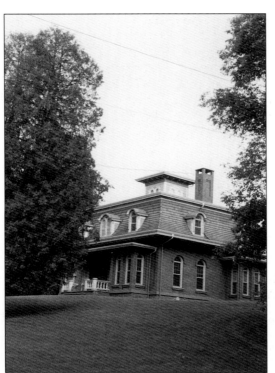

THE G.G. MANNING HOUSE. This house on Ithaca Street in Waverly was built in the French Second Empire style in about 1860 or 1861 by Mr. Manning, who was in the dry goods and mercantile businesses. He also held the public positions of Town of Barton supervisor and justice of the peace. The house was a station on the Underground Railroad.

THE CHARLES SHEPARD HOUSE. John Shepard's grandson Charles built this house off Chemung Street in Waverly in about 1860 in the popular Italianate style. Charles was an original stock holder in the Waverly Paper Mill. This house remained in the Shepard family until 1951. (Photograph courtesy of Destiny Kinal.)

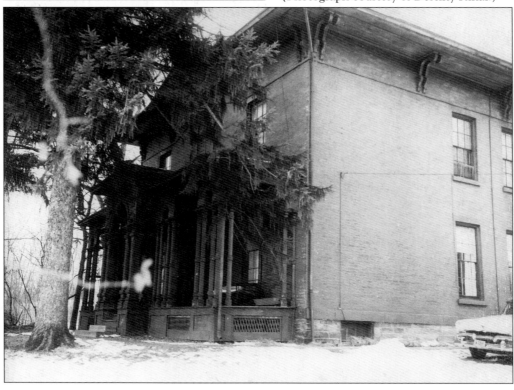

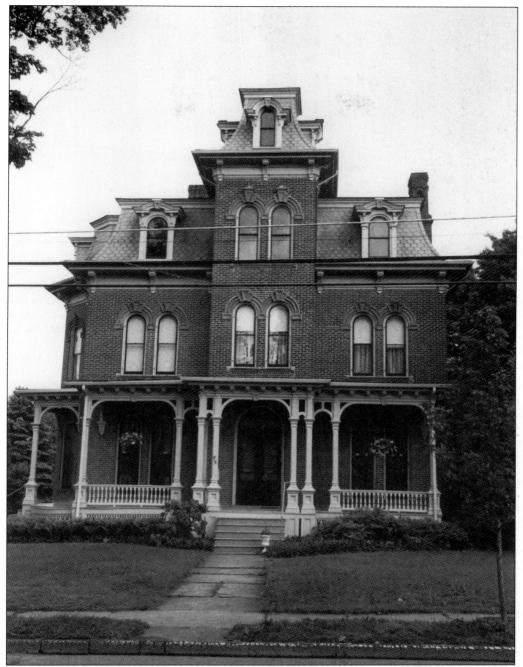

THE CHARLES SAWYER RESIDENCE. This imposing house on Chemung Street in Waverly is a very good example of the Second Empire style of architecture. It was built in 1869–70.

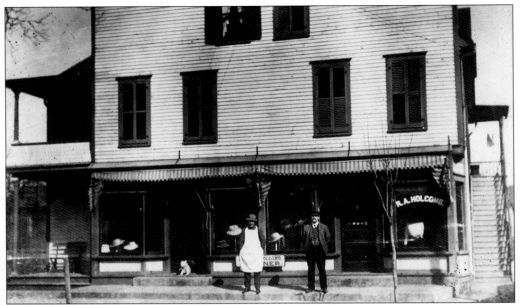

R.A. HOLCOMB, MILLINER. In 1870, Waverly banker Howard Elmer and some other investors purchased the land that was to become Sayre. In the beginning the town was planned west of the area that finally ended up as the town center. A long, straight avenue, Keystone Avenue, was laid out, then the center was relocated to the junction of the railroads. This did not stop businesses, such as this one, from locating along Keystone Avenue.

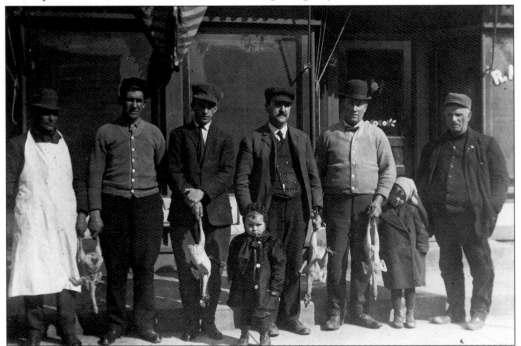

WEST SAYRE. Two of the same men in the previous photograph also appear in this one, taken in front of the same building at 423 South Keystone Avenue in Sayre on the same day.

THE WEST SAYRE PHARMACY. The pharmacy shared a building with O.S. Warner. The building still stands at 428 South Keystone Avenue.

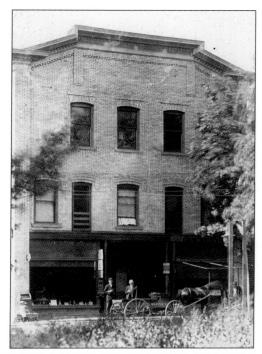

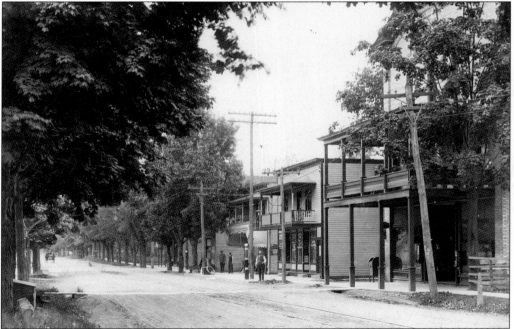

KEYSTONE AVENUE. One of the reasons this area was able to thrive was the coming of the trolley in 1894. The tracks can be seen in this picture, as well as a plank sidewalk. The sidewalks were paved, but the road was not. Far down the street a horse-drawn buggy approaches. The building on the right in this photograph is the same as the one in the previous picture, but here it sports a porch and balcony.

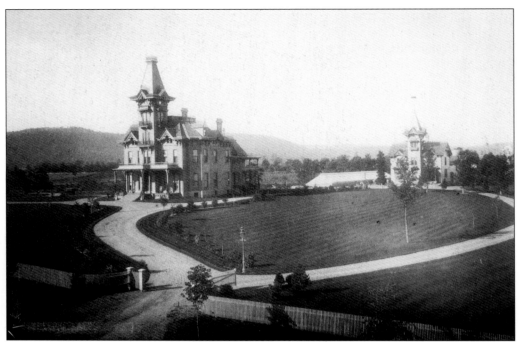

THE PACKER MANSION. Robert Packer constructed this mansion, completed in 1877, as a home for himself and his wife, Emily Piolett Packer. Packer was a railroad man who invested in the future of Sayre. Sadly, the Packers only lived in the home for six years. When Mr. Packer died in Florida in 1883, the house passed to his sister Mary, who donated the building to be used as a hospital, named the Robert Packer Hospital in memory of her brother.

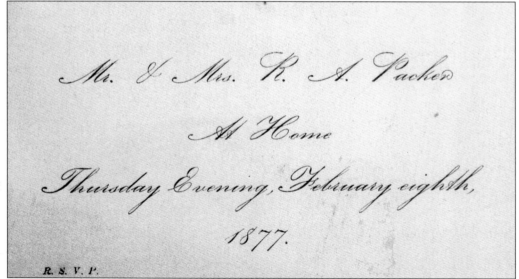

A HOUSEWARMING INVITATION. In her book *Sayre and Early Valley History*, Elizabeth Wilcox writes: "A notable event was the housewarming given by Mr. and Mrs. Packer on the completion of their home in 1877. There were guests from Waverly, Sayre, Athens and Towanda. Those coming from Towanda came by special train provided by Mr. Packer."

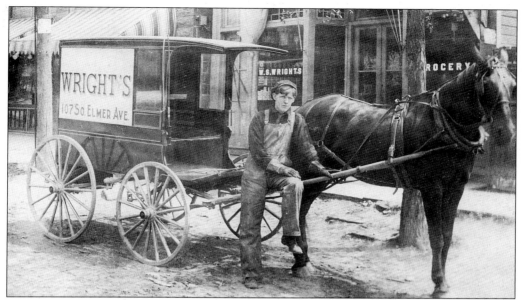

W.S. WRIGHT'S GROCERY. This store was located at 107 South Elmer Avenue, as the sign on the side of the buggy says. The building next to it is the four-story block on the corner of Elmer and Lockhart. Note the tree in the street behind the horse.

THE TUTTLE-GLASER HOUSE. This 1893 picture shows the stick-style house built in 1883 by Dr. Tuttle at 201 South Elmer Avenue in Sayre. He lived in the left half of the house and there was a separate entrance on the other side for his patients. Later the Glaser family bought the house and members of that family have lived here for most of this century. (Photograph courtesy of Mollie Caplan.)

THE HOUSE OF CHARLES KELLOGG. Charles Kellogg was the founder of the Athens Bridge Works. He had been constructing wooden railroad bridges and decided to locate a company in Athens to make prefabricated bridges. In 1872 he built this Queen Anne-style house on South Main Street in Athens.

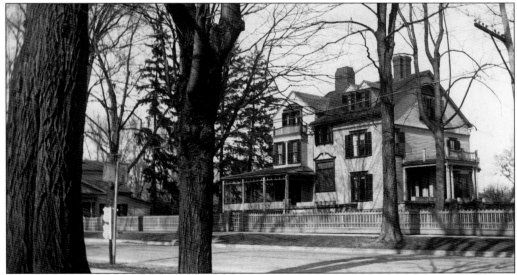

THE MAURICE HOUSE. Mr. Maurice joined Mr. Kellogg in the bridge-making business in 1871. Mr. Maurice had sold his interest in a tannery across the Chemung, and together the two men decided to make iron and steel bridges at the Athens plant. The Maurice family had far-ranging interests. They owned a winter home on Jekyll Island in Georgia and this eclectic one, built on South Main Street in Athens in 1882.

THE MAURICE SISTERS.
C.S. Maurice married Charlotte Marshall Holbrooke in 1869 and they had nine children. Four of their daughters are shown in this photograph, taken about 1904. They are, from left to right: Marian, Emily, Margaret, and Cordelia. Marian and Margaret never married. They stayed in Athens for their whole lives; when Margaret died in 1958 the house (see opposite page) passed out of the family.

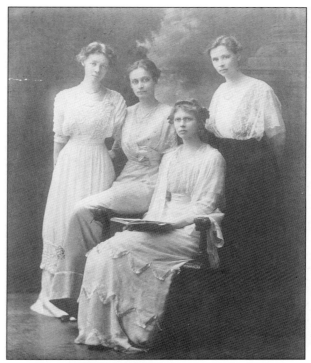

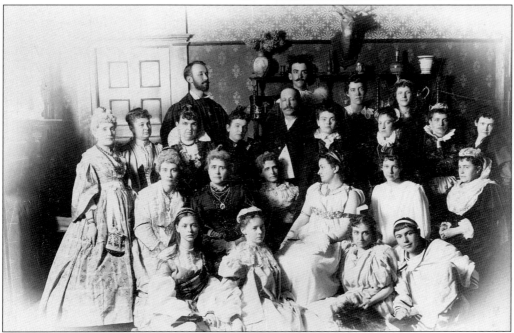

A FANCY DRESS PARTY OF THE PROGRESS CLUB. A party took place at the Maurice residence in March 1894. This picture was taken in the dining room. Among those present were members of many Valley families including the Canfields, MacAfees, Saterlee, Thurston, Park, Corbin, and others.

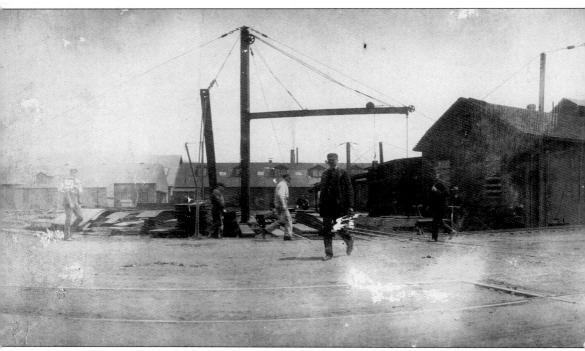

THE ATHENS BRIDGE WORKS (ABOVE AND OPPOSITE). Athens shipped bridges all over the world, to places as far as Australia and London and as close as Elmira. The company also made their own tools because they were not available for purchase. There were pattern, foundry, machine, rivet, and blacksmith shops. In 1884 the company merged with the Union Bridge Company and later with the American Bridge Company. It was in business until 1910. The Ingersoll-Rand plant now occupies some of the land formerly used by the bridge company. The photograph below shows the office staff in 1887.

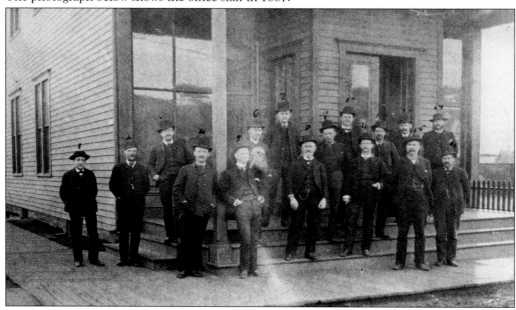

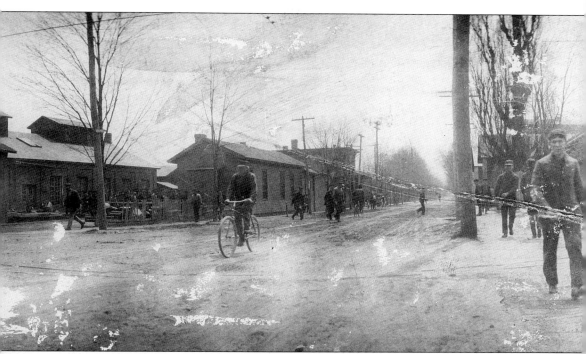

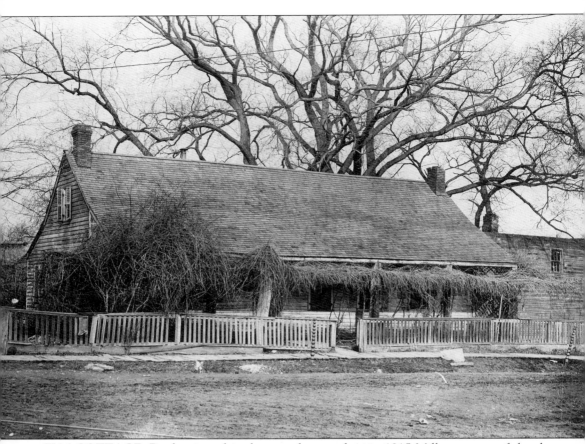

ELM COTTAGE. By the time this photograoh was taken in 1915 Milltown, one of the the earliest settlements in the Valley, had become part of Sayre. This was Dr. Amos Prentice's cottage at Spring's Corners. It was about one hundred years old and had fallen into disrepair.

Three
Modern Times

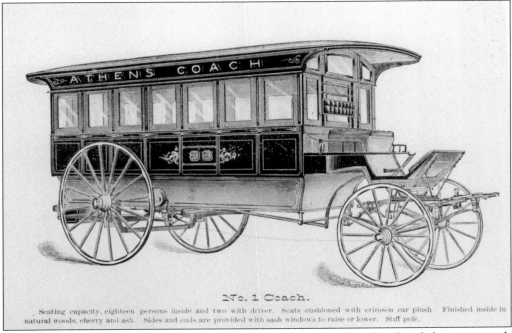

No. 1 Coach.

Seating capacity, eighteen persons inside and two with driver. Seats cushioned with crimson car plush. Finished inside in natural woods, cherry and ash. Sides and ends are provided with sash windows to raise or lower. Stiff pole.

THE ATHENS CAR AND COACH COMPANY. By the last decade of the nineteenth century, changes were coming too fast for some to keep up, but they tried. The Athens Car and Coach company made coaches to compete directly with street cars and its brochure lists seven advantages of the Athens coach over street car lines. The public wasn't buying it.

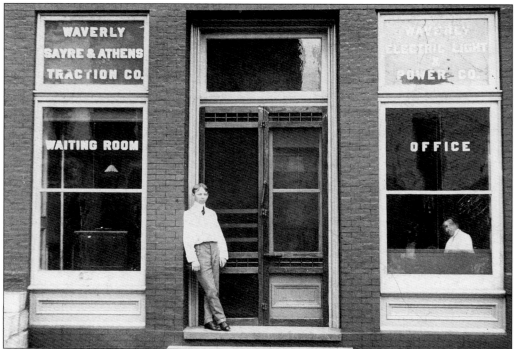

THE OFFICE AND WAITING ROOM OF THE WAVERLY, SAYRE & ATHENS TRACTION COMPANY. The trolley commenced operation in June of 1896. Valley residents could board a rail car in Waverly at Fulton and Broad and travel as far as the Lehigh Valley Railroad station in Athens, changing cars once, because the W., S. & A. did not have the right of way to cross the Lehigh Valley tracks at Spring Street, Sayre. This inconvenience ended when a bridge was built over the crossing.

A LINE CREW OF THE W., S. & A. TRACTION CO. This photograph was taken at the rear of 332 Fulton Street, South Waverly, about 1902. On the left are Warren Case (taller) and Almet Case; kneeling is Clark Tobias. The man standing on the right has not been conclusively identified.

50

W., S. & A. TRACTION CO.

WAVERLY, SAYRE AND ATHENS LINE.

First car will leave Waverly for Sayre and Athens at 5:40 a. m., and every twenty minutes thereafter up to and including the 10:40 p. m. car. Next car will leave Waverly for Sayre and Athens at 11:20 p. m.

First car will leave Sayre for Waverly at 6:40 a. m. and every twenty minutes thereafter up to and including the 11:40 p. m. car.

First car will leave Athens for Sayre and Waverly at 6:20 a. m. and every twenty minutes thereafter up to and including the 11:20 p. m. car.

SOUTH Streets and Avenues				NORTH Streets and Avenues			
Fulton St., Waverly	20	40	60	White Gate, Athens	20	40	60
East Broad St. Switch	24	44	04	Tioga St., Athens	21	41	01
Broad St. & Cayuta Ave.	25	45	05	Postoffice, Athens	25	45	05
Spring's Cor. Sfith.	30	50	10	Pine St. Switch	30	50	10
Mohawk St. & Elmer Ave	33	53	13	Hayden's Corner	34	54	11
Lehigh Station, Sayre.	38	58	18	Wilbur House, Sayre	38	58	18
Wilbur House, Sayre	40	60	20	Lehigh Station, Sayre	40	60	20
Hayden's Corner	45	05	25	Mohawk St. & Elmer Ave.	46	06	26
Pine St. Switch	50	10	30	Spring's Corner Switch.	50	10	30
Postoffice, Athens	54	14	34	Broad & Cayuta Ave.	53	13	33
Tioga St., Athens	57	17	37	East Broad St. Switch	54	14	34
White Gate, Athens	60	20	40	Fulton St., Waverly	59	19	39

WAVERLY, SOUTH WAVERLY AND SAYRE LINE.

First car will leave Fulton St., Waverly, for South Waverly and Sayre at 5:30 a. m.

Next car will leave Waverly for South Waverly and Sayre at 6:10 a. m. and every twenty minutes thereafter up to and including the 10:30 p. m. car.

Next car will leave Waverly for South Waverly and Sayre at 11:10 p. m.

First car will leave Sayre for South Waverly and Waverly at 5:50 a. m.

Next car will leave Sayre for South Waverly and Waverly at 6:30 a. m. and every twenty minutes thereafter up to and including the 10:10 p. m. car.

Next car will leave Sayre for South Waverly and Waverly at 10:50 p. m.

SOUTH Streets and Avenues			
Fulton St., Waverly	10	30	50
D. L. & W. Station	15	35	55
Zausmer's Switch	20	40	60
Keystone Park	21	41	01
Keystone Ave. & Lockhart	23	43	03
Lehigh Station, Sayre	28	48	08
Wilbur House, Sayre	29	49	09

NORTH Streets and Avenues			
Wilbur House, Sayre	30	50	10
Lehigh Station, Sayre	31	51	11
Keystone Ave. & Lockhart	36	56	16
Keystone Park	38	58	18
Zausmer's Switch	40	60	20
D. L. & W. Station	45	05	25
Fulton St., Waverly	60	10	30

CLINTON AVENUE LINE

First car will leave Fulton street for Pine street and East Waverly at 6:10 a. m. and every twenty minutes thereafter up to and including the 11:30 p. m. car.

Streets and Avenues			
Fulton St., Waverly	30	50	10
Pine St. & Clinton Ave.	34	54	14
William & Chemung Sts.	38	58	18
East Waverly	40	60	20
Broad St. & Cayuta Ave.	42	02	22
East Broad St. Switch	44	04	24
Fulton St., Waverly	49	09	29

Special car service can be arranged for at the Broad street office, Waverly, N. Y., or by calling E. L. Pickley, car barn. Both phones.

All night service every hour after midnight.

ALL NIGHT CAR—W. S. & A. LINE AND S. W. & SAYRE LINE.

NOTE:—The all night car leaves Waverly every trip via Waverly, Sayre & Athens Line, returning from Athens to Waverly via Waverly, South Waverly & Sayre Line, except the 5:30 a. m. trip out of Athens which will be made to Waverly via W. S. & A. Line. Passengers for Athens at the D. L. & W. Station after midnight will be charged 10 cents; five cents to Sayre via Waverly and five cents from Sayre to Athens.

SOUTH		a. m.	a. m.	a. m.	a. m.	a. m.	a. m.
Waverly, Fulton Street	Ar.	12:00	1:00	2:00	3:00	4:00	5:00
Car Barn		12:08	1:08	2:08	3:08	4:08	5:08
Sayre, L. V. Station		12:15	1:15	2:15	3:15	4:15	5:15
Athens, Elmira Street		12:30	1:30	2:30	3:30	4:30	5:30
NORTH							
Athens, Elmira Street	Lv.	12:30	1:30	2:30	3:30	4:30	5:30
Sayre, L. V. Station		12:45	1:45	2:45	3:45	4:45	5:45
Car Barn							5:50
D., L. & W. Station, Waverly		12:55	1:55	2:55	3:55	4:55	
Fulton Street, Waverly		1:00	2:00	3:00	4:00	5:00	6:00

W. E. CASE, Supt.

TIME TABLE. This table shows the extent of the trolley service in 1917. It was easy to get from one place in the Valley to another during the thirty-four years that the W., S. & A. operated. In 1930, because its Sayre franchise had been revoked and because of the Depression, the W., S. & A. ceased operation.

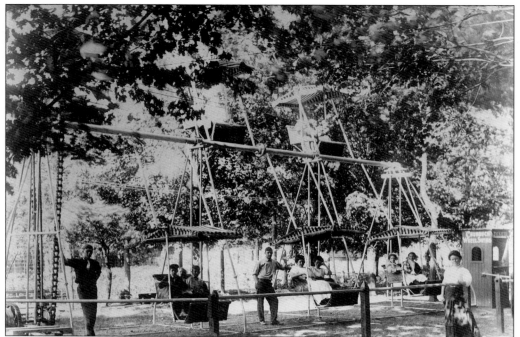

KEYSTONE PARK, THE CHUBBUCK WHEEL SWING. Keystone Park was built by the W., S. & A. Traction Company in 1908 to increase ridership. Admission to the park was free to those who rode there on the trolley, otherwise it cost 5¢ to get in (the same as it cost to ride). This swing was one of the rides and was powered by streetcar motors.

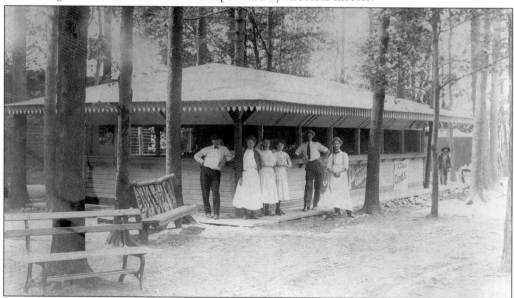

KEYSTONE PARK, THE SNACK BAR. The park was located in a grove with rustic benches placed about. The structures had distinctive tooth-like trim that can still be seen today on the Keystone Roller Rink. Peanuts and ice cream cones were among the snacks that could be purchased at this stand.

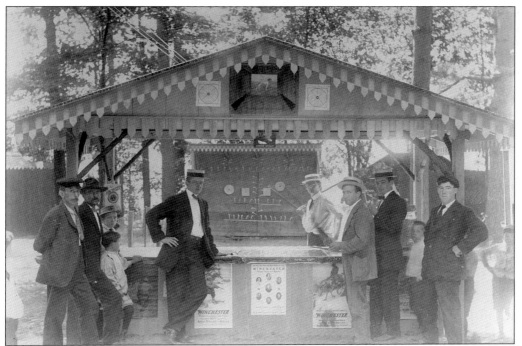

THE SHOOTING GALLERY AT KEYSTONE PARK. This was such a popular spot that another shooting gallery had to open elsewhere in the park on particularly busy days.

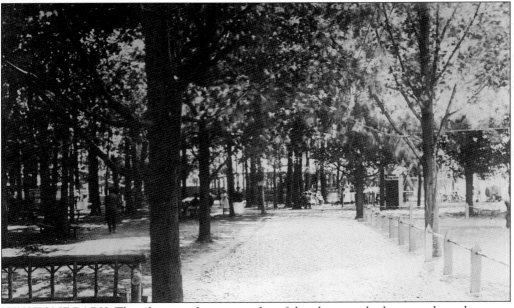

KEYSTONE PARK. This photograph gives an idea of the pleasant, shady atmosphere that must have existed at the park. Compare it to the hot, treeless amusement parks of today. Keystone Park closed in 1919 because the W., S. & A. did not want to pay to have its section of Keystone Avenue paved; it no longer ran trolleys past the park. Others purchased the land and ran the park, but it never did as well as it had during the days of the streetcars.

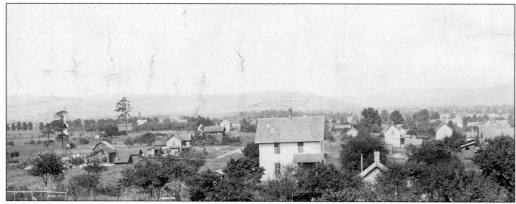

NORTH MAIN STREET, ATHENS, 1890. This photograph shows a rare view of the area. There was still a large expanse of fields between North Athens and Sayre, but it was steadily filling in.

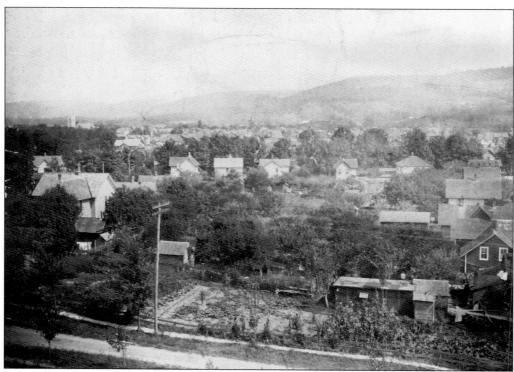

UPPER ATHENS, 1890. This is a part of town of which few photographs of this era exist. Private vegetable gardens are visible in the front. Off in the distance, on the left side, is the Packer mansion, and just to the right of that is the Church of the Redeemer, both in Sayre.

THE H.P. CHAFFEE BOOT AND SHOE STORE. This store was located opposite Susquehanna Street in Athens. Their advertisement says that they carry shoes: "To suit your Pocket book, your Taste, your Requirements."

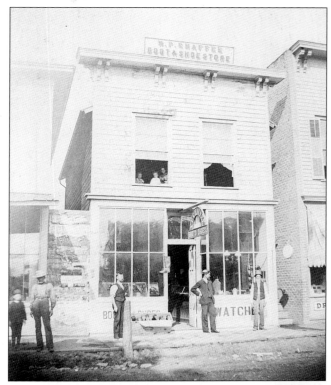

SOUTH MAIN STREET, ATHENS. Few, if any, of these buildings are still standing. (Photograph courtesy of Henry Farley.)

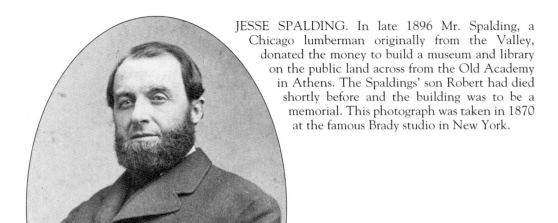

JESSE SPALDING. In late 1896 Mr. Spalding, a Chicago lumberman originally from the Valley, donated the money to build a museum and library on the public land across from the Old Academy in Athens. The Spaldings' son Robert had died shortly before and the building was to be a memorial. This photograph was taken in 1870 at the famous Brady studio in New York.

LOUISE WELLES MURRAY (1854–1931). In 1895 Mrs. Murray was instrumental in the formation of a museum, upstairs in the Old Academy, for the Tioga Point Historical Society. She became the first director of the Tioga Point Museum and remained in that position until her death. Mrs. Murray wrote the definitive history *Old Tioga Point and Early Athens* in 1908.

HARRIET ALLEN THURSTON (1852–1914). Mrs. Thurston was among a group of women who volunteered to run the Athens Library when it was first formed. She became its first librarian, and was succeeded in that position by her daughter, Miss Helen Thurston, who remained librarian for forty-five years. (Photograph courtesy of John Thurston.)

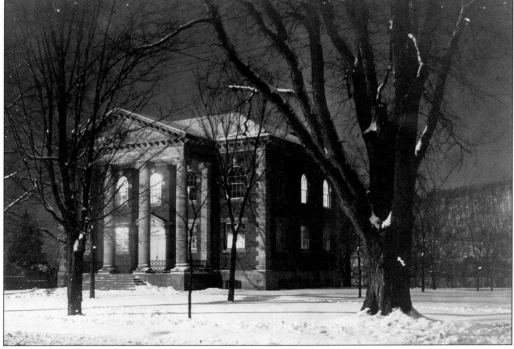

THE SPALDING MEMORIAL LIBRARY-MUSEUM BUILDING. This is the fine Colonial Revival building that resulted from the generosity of Jesse Spalding. For almost one hundred years, since it opened in 1898, it has housed the library on the first floor and the museum on the second.

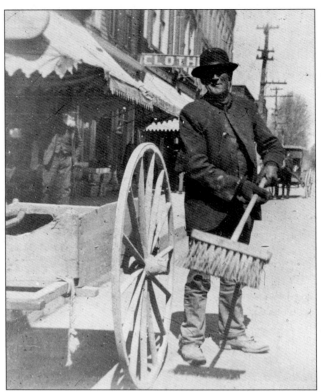

CLEAN-UP DAY IN 1900. This fellow on Main Street in Athens had his work cut out for him, as the streets of Athens had not yet been paved.

A BLACKSMITH SHOP. There were several blacksmiths in Athens at the time this picture was taken (1890s). All we know is that this one was on Susquehanna Street. Horseshoes hang over the barrel edges, on the walls, and from the rafters.

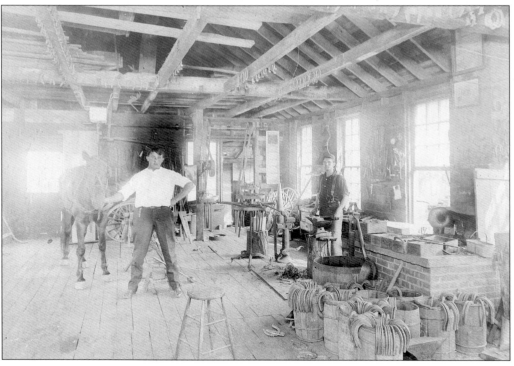

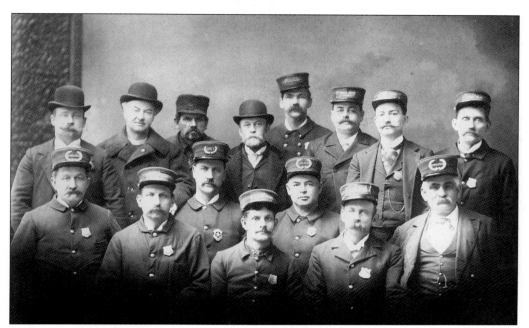

THE ATHENS HONORARY POLICE DEPARTMENT, ABOUT 1901. Some of the men who have been identified are: Dan O'Brien (fourth from the left, bottom row), Abraham Groat (sixth from the left, bottom row), and Police Chief Bob Mulligan (top row, seventh from the left).

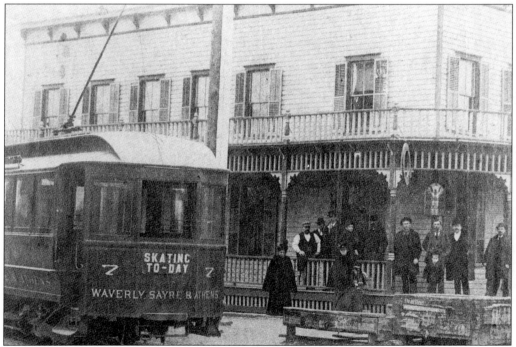

A TROLLEY IN FRONT OF EAST WAVERLY HOTEL (1907). This hotel stood at the corner of Ithaca Street and Cayuta Avenue. (Photograph courtesy of Don Merrill.)

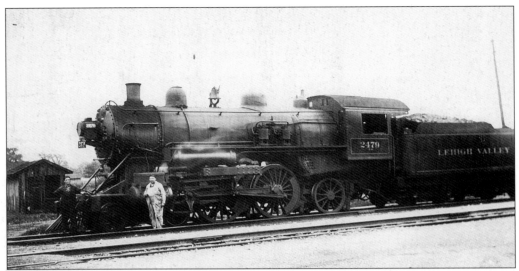

LEHIGH VALLEY ENGINE 2479. This engine was built in the Sayre shops. The engineer was Charles E. Mekeel and William Davis was the fireman. The photograph was taken near Milan.

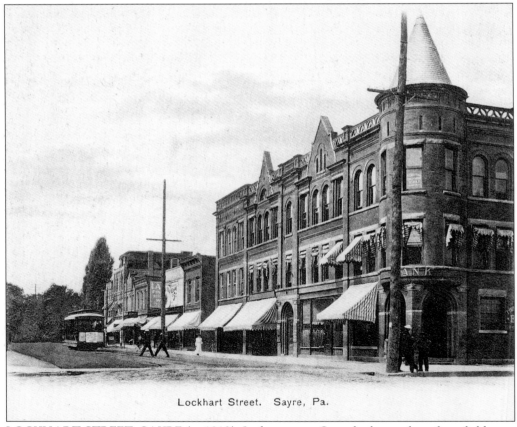

Lockhart Street. Sayre, Pa.

LOCKHART STREET, SAYRE (c. 1912). In forty years, Sayre had gone from farm fields to a busy town with large brick buildings. This is a scene of Lockhart Street looking west.

THE WEDDING OF ELLEN COVEWEY AND JOHN CAIN. The bride came from Pond Hill and the groom from Ridgebury, but they made their home in Sayre. The wedding took place on October 15, 1901. Of special note is their fine wedding attire. (Photograph courtesy of Henry Farley.)

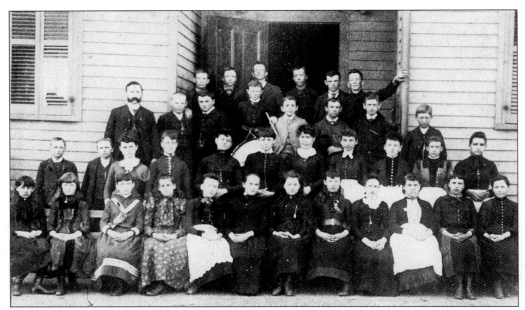

THE GRADUATING CLASS OF 1889, SAYRE HIGH SCHOOL. The man with the impressive mustache is the principal, L. Baxter.

EDWIN C. MILLER. Mr. Miller of Waverly was a machinist who did very fine work. He built a working scale model of a locomotive, the E.C. Miller, now in the collection of the Tioga Point Museum.

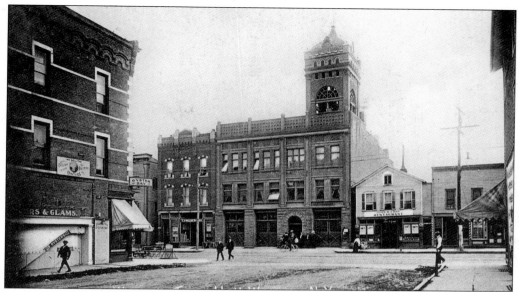

THE WAVERLY VILLAGE HALL. This building was erected in 1892 on Broad Street. (Photograph courtesy of the Waverly Free Library.)

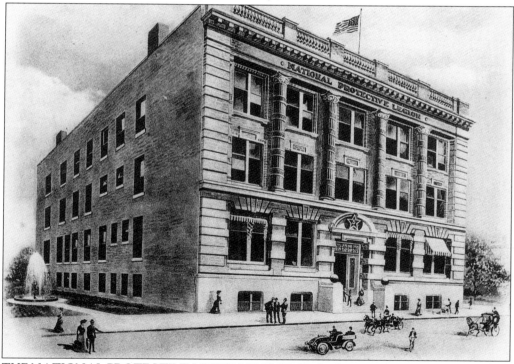

THE NATIONAL PROTECTIVE LEGION BUILDING. In the program to Old Home Week, (see p. 108) published by the National Protective Legion, a fraternal insurance institution, this organization defines itself as "Waverly's greatest financial and industrial enterprise" and asks people to "note the great improvements to the town as a result of Legionism within it." (Photograph courtesy of the Waverly Free Library.)

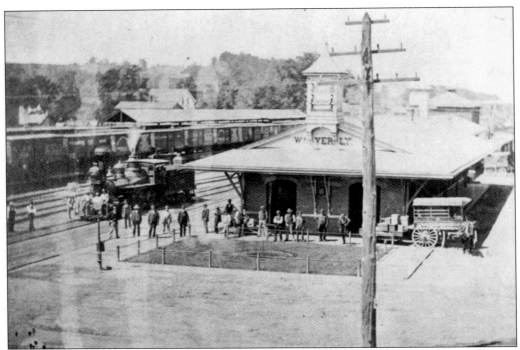

ERIE DEPOT, WAVERLY. In 1880 the station had a clock tower. The area to the southwest was still only lightly developed. (Photograph courtesy of Don Merrill.)

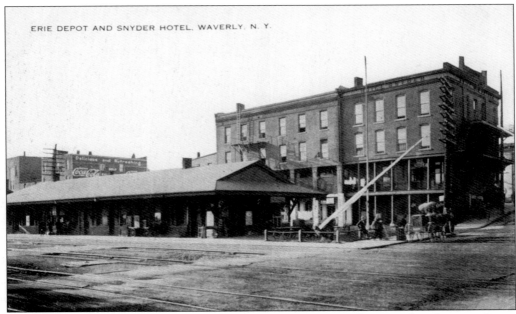

ERIE DEPOT AND THE SNYDER HOTEL, WAVERLY. By the time this photograph was taken around the turn of the century, the clock had been removed. The large hotel behind the station catered to the busy rail traffic. (Photograph courtesy of the Waverly Free Library.)

THE HOUSE AT 150 CHEMUNG STREET, WAVERLY. This was the home of the Falsey family. Mary and Ellen Falsey stand on the front porch. (Photograph courtesy of Henry Farley.)

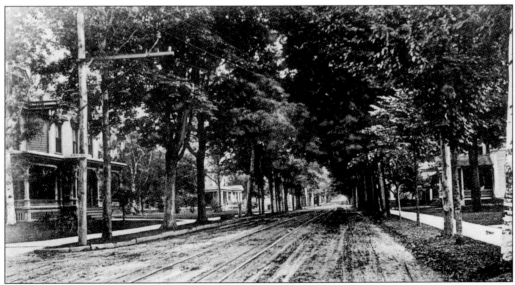

CHEMUNG STREET, WEST WAVERLY. Trolley tracks can be seen in this view of the intersection of Chemung and Athens Streets. (Photograph courtesy of the Waverly Free Library.)

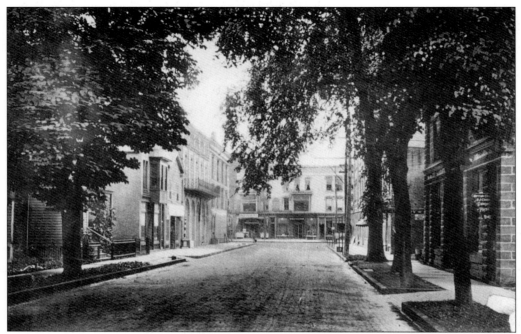

WAVERLY STREET, WAVERLY. On the right-hand side of the picture, in the stone building, were the offices of a pair of osteopathic physicians. (Photograph courtesy of the Waverly Free Library.)

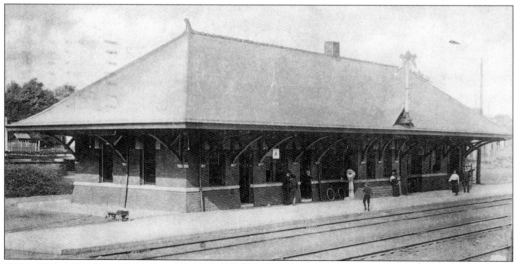

THE DELAWARE AND LACKAWANNA STATION, WAVERLY. In 1907 there were several railroad stations in Waverly: this one for the Delaware, Lackawanna and Western, another for the Erie, and yet another for the Lehigh Valley. (Photograph courtesy of Don Merrill.)

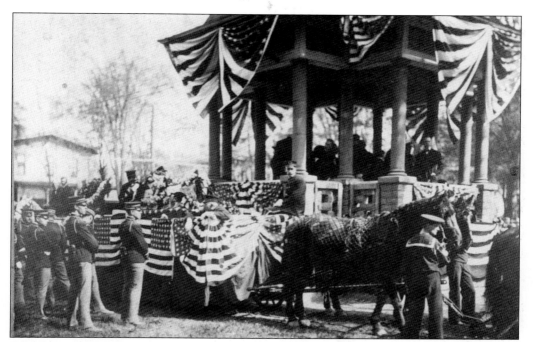

THE BANDSTAND, WAVERLY. Probably taken in 1910, this picture shows the bandstand in Muldoon Park. Concerts were played here regularly. (Photograph courtesy of Don Merrill.)

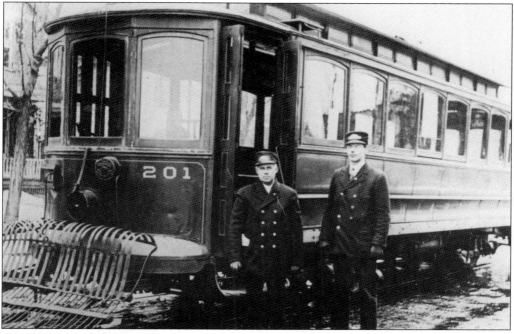

TROLLEY 201. The Waverly, Sayre & Athens Traction Company was not the only company to operate trolleys in the area. Large trolleys ran from Waverly to Elmira and Corning hourly in the 1920s. The man on the left is Dan Lennox, conductor. (Photograph courtesy of Don Merrill.)

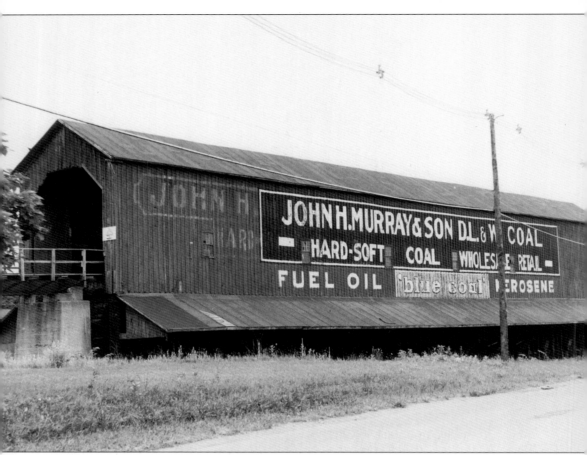

JOHN H. MURRAY & SON. This coal storage barn has been a familiar sight in the Valley for many years.

Four
Boom Towns

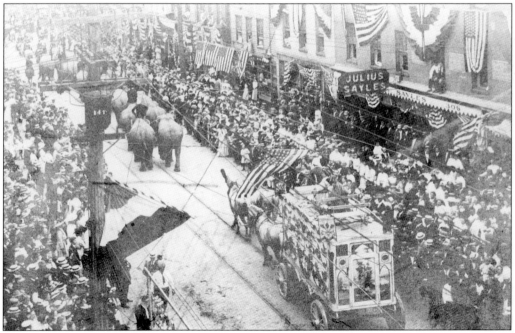

CIRCUS DAY, OLD HOME WEEK. In August 1910, Waverly held a homecoming celebration during which family reunions, concerts, and other events took place. On Tuesday, August 23, the Forepaugh & Sells Brothers' Circus came to town. (Photograph courtesy of Don Merrill.)

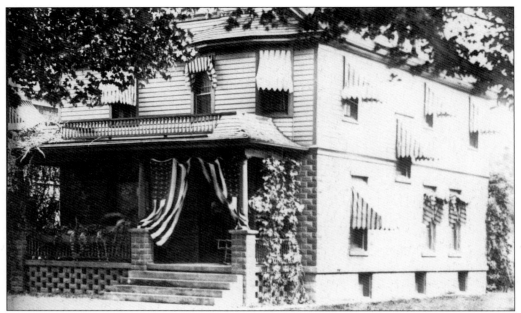

OLD HOME WEEK. This new house at 318 Chemung Street was one of the many decorated with bunting and flags for the festivities. There was a parade every day, including a baby parade on Monday with three divisions: girls with doll coaches, boys with wagons, and babies in carriages and go-carts. Winners took home five-dollar gold pieces. (Photograph courtesy of Don Merrill.)

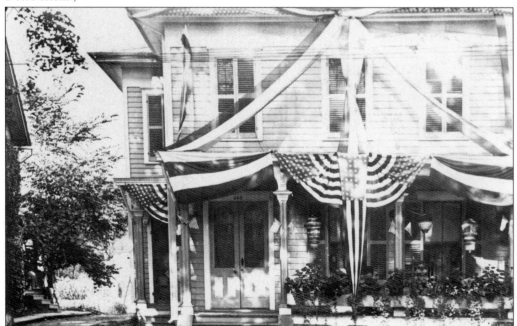

OLD HOME WEEK. People took pride in the decoration of their homes. On Saturday, August 27, it was "Gala night on the Midway." There were fireworks and concert performances. (Photograph courtesy of Don Merrill.)

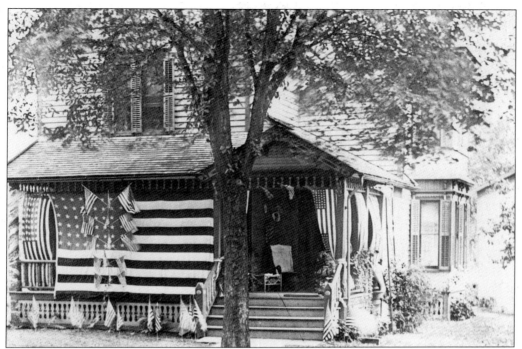

OLD HOME WEEK. Other events during the week included a reunion of Grand Army of the Republic veterans of Bradford, Chemung, and Tioga Counties with a banquet and Camp Fire, speeches, and the presentation of a cane to an Andersonville prisoner. (Photograph courtesy of Don Merrill.)

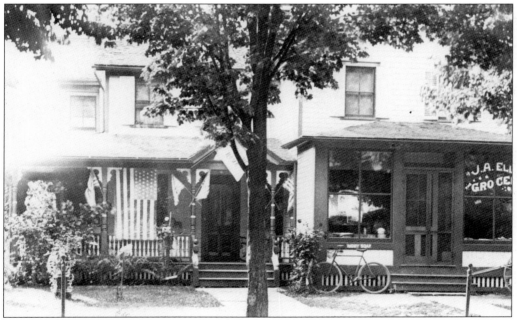

OLD HOME WEEK. This home and business at 21 Lincoln Street flies a flag saying "Welcome Home." (Photograph courtesy of Don Merrill.)

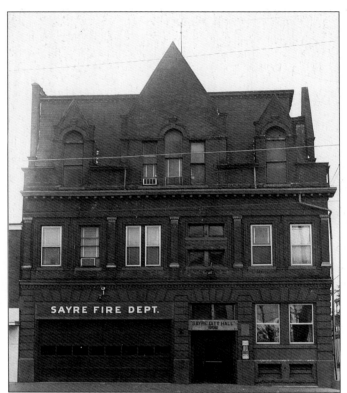

THE SAYRE CITY HALL.
In 1908 the Sayre City Hall,
which also housed the
Wilbur and Packer volunteer
fire companies, was built.
Originally there were two
doors for the fire trucks.

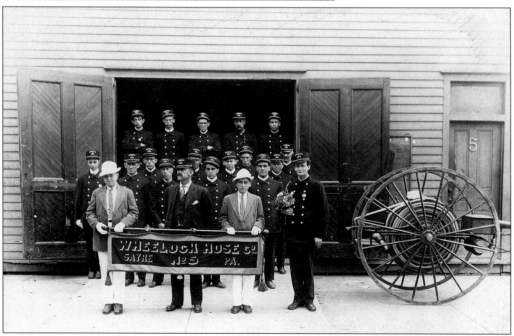

THE WHEELOCK HOSE COMPANY. Another Sayre volunteer fire-fighting organization, the Wheelock Hose company, was formed in 1898. Here is its membership on August 17, 1912.

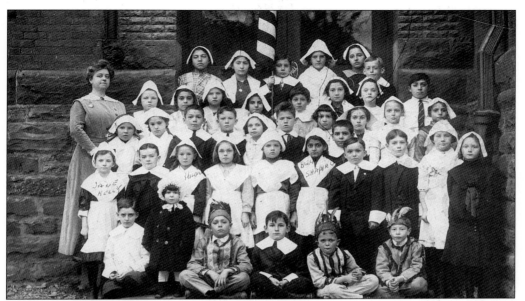

THE FOURTH WARD SCHOOL, SAYRE (*c*. 1910). The members of this class are dressed as Pilgrims and Indians. The student who saved this picture, Hildred Tyler (second row, third from left), had two similar pictures from different years, so this must have been an annual event. The teacher was Miss Wells. (Photograph courtesy of Mollie Caplan.)

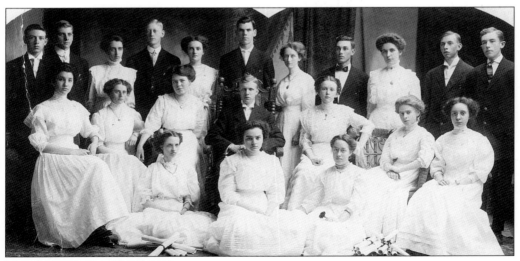

THE SAYRE CLASS OF 1910.

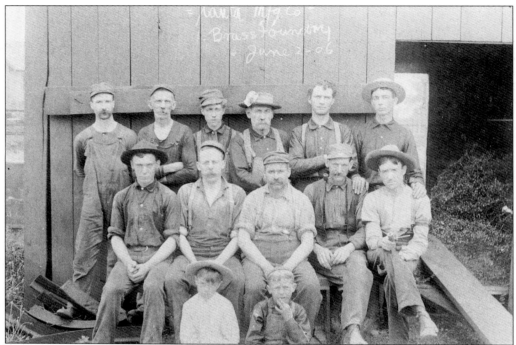

THE CAYUTA MANUFACTURING COMPANY. On June 2, 1906, these workers at the brass foundry paused to smoke their pipes and sit for this picture. The company was located in Waverly. (Photograph courtesy of Don Merrill.)

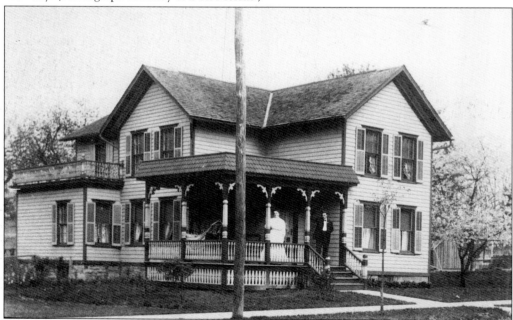

A HOUSE ON PINE STREET, WAVERLY. This house at 21 Pine Street still stands. At the time this photograph was taken, in the 1920s, the Neaves family lived here. (Photograph courtesy of Don Merrill.)

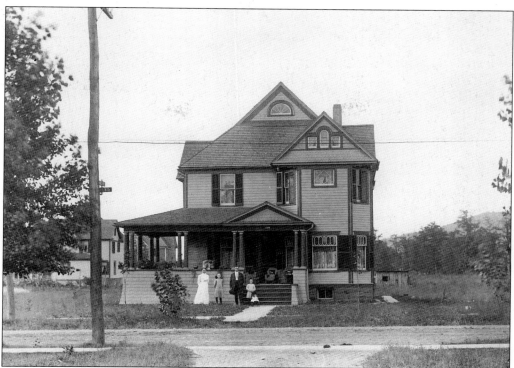

THE HOME AT 409 LINCOLN STREET, SAYRE. In 1928 this house was owned by Bruce S. Griffis, a commercial traveler, and Bernice and Minnie Griffis, both teachers.

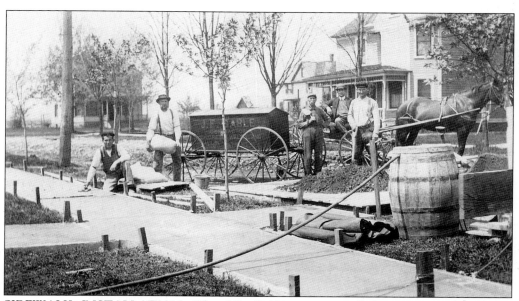

SIDEWALK INSTALLATION. The J.F. Gable crew installed concrete sidewalks in neighborhoods around the Valley. His address was 608 Church Street in Athens. He advertised "Best of Sidewalks, Foundations, Curbs, &c."

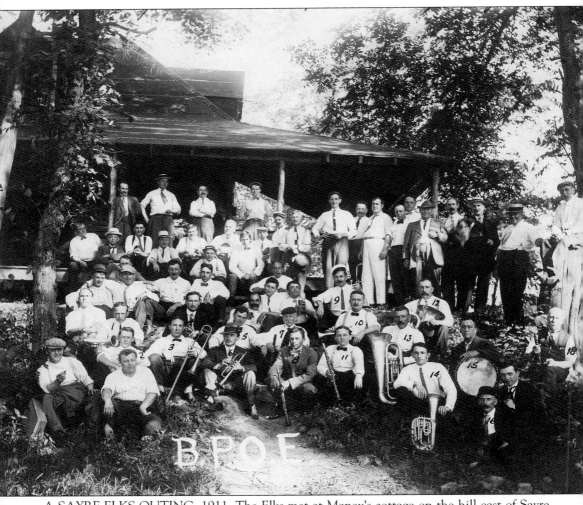

A SAYRE ELKS OUTING, 1911. The Elks met at Maney's cottage on the hill east of Sayre, about 200 yards from the east end of the Susquehanna bridge. The cottage was destroyed by fire many years ago. Entertainment was provided by a band of eighteen members, five of whom were from the Daly family.

HARLAN ROWE, *c.* 1915. Although Harlan (shown to the right) is standing still and dressed nicely for this picture, the dog is the star. Harlan grew up to be involved in education as a long-standing member of the Athens School Board. In 1974 the borough of Athens honored him by naming the middle school after him. His brother Adrian (shown to the left) also became invloved in education, as a teacher in Galeton.

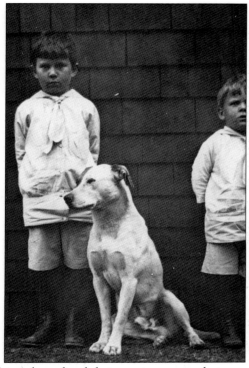

THE DIAHOGA HOSE COMPANY (1915). This Athens fire-fighting unit poses in their striped uniforms, complete with white gloves and caps with shiny brims.

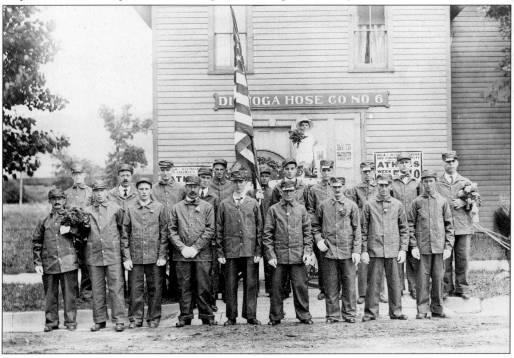

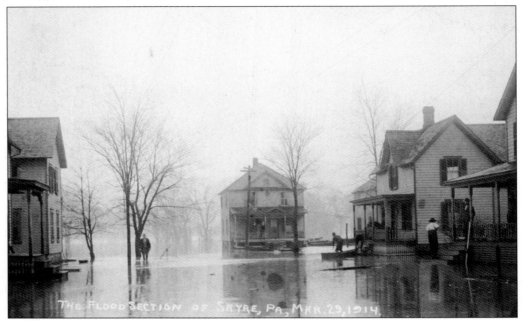

A FLOOD IN SAYRE, 1914. Flooding has always been a risk in the valley, and occasionally there is boating in the streets. This flood happened on March 29, 1914.

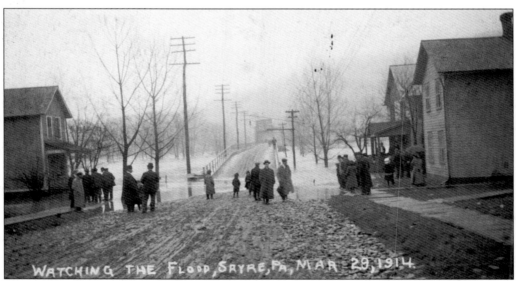

WATCHING THE FLOOD, SAYRE, 1914. This is the same flood seen looking toward the bridge over the Susquehanna. There were other flood years, of course, and high water is a perennial occurrence, usually at the spring thaw, but often at other times of the year as well.

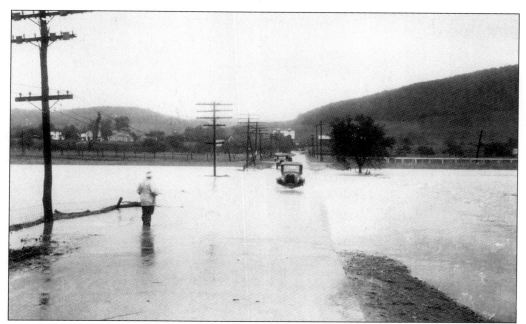

A FLOOD IN EAST ATHENS. This may be the same flood, or it could have happened later. This is the area just across the bridge over the Susquehanna from Athens. Then, as now, drivers made guesses about the depth of the water and decided whether or not to take the risk of driving through.

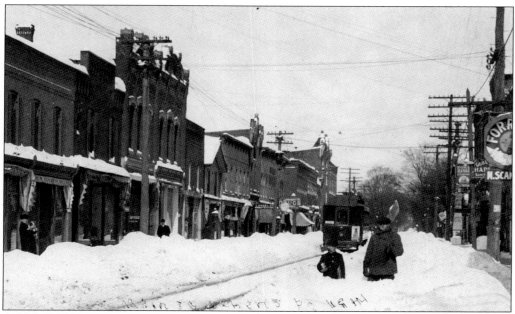

A BIG SNOW, 1914. Sometimes the whole year is remembered for bad weather. Here are the remains of a big snow in downtown Athens. There is room for the trolley, and the sidewalks have been cleared, but everything else is covered. Getting from the walk to the trolley must have been . . . interesting.

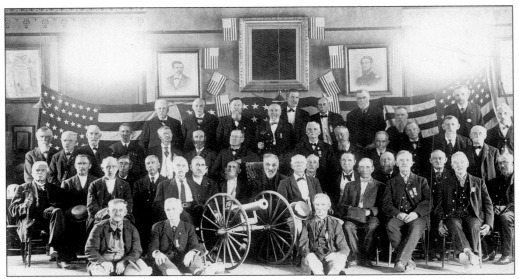

THE PERKINS POST, G.A.R., *c.* 1915. There were many Civil War veterans among the residents of the Valley. The Perkins Post of the Grand Army of the Republic was the Athens organization. Judging from the age of the men, this gathering probably took place around 1915.

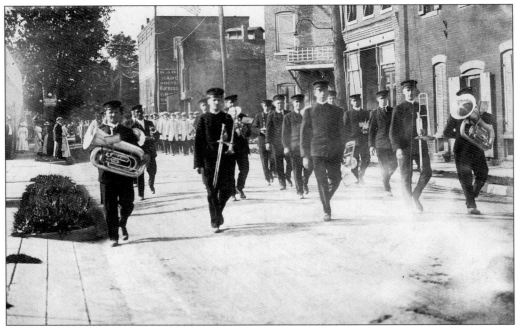

THE ATHENS BAND. The Perkins Post of the G.A.R. is the three-story building visible in the background of this picture. It was built in 1886 and demolished in 1943. This parade is moving along Elmira Street toward the intersection with South Main.

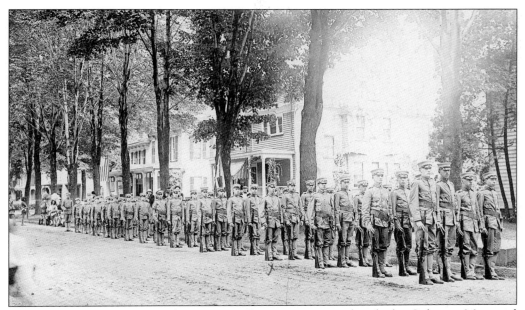

THE BOYS BATTALION. The Boys Batallion was associated with the Coleman Memorial Parish House of the Church of the Redeemer. Members drilled on Monday nights and marched in parades. Some clowns can be seen waiting behind the boys in this parade. The boys also stayed at Camp Asa Packer near Milan.

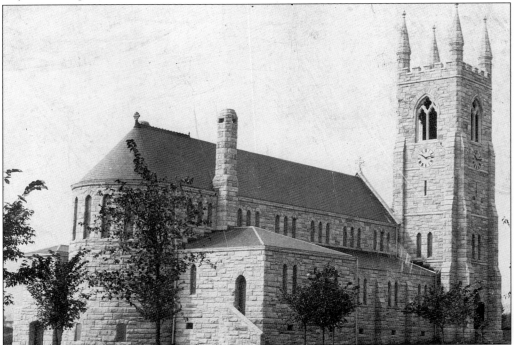

THE CHURCH OF THE REDEEMER, SAYRE. Mary Packer Cummings, sister of Robert Packer, donated the funds to build this church in 1888–89. It stands at the corner of South Wilbur Avenue and Park Place in Sayre.

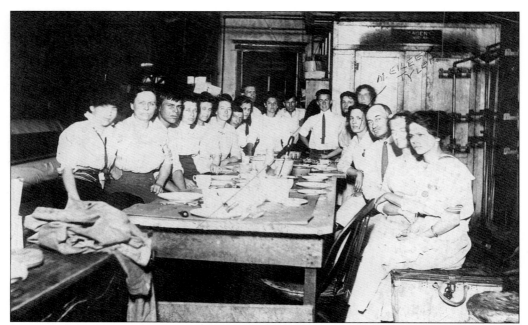

PERFECTION LAUNDRY, 229 DESMOND STREET, SAYRE. The ads read: "Where Linen Lasts." The employees are, from left to right: Catherine Biles, Grace Biles, Leslie House, Mrs. Bertram, Miss Rolfic, Mrs. Jannett, Alf Horn, Alfie House, Frank Horn (manager), Pauline Thompson, Ed Horn, George Smith, Letha Truesdale, Nina Douglas, M. Eileen Tyler, John Smith, Mrs. Lily Kent, and Elizabeth Biles. (Photograph courtesy of Mollie Caplan.)

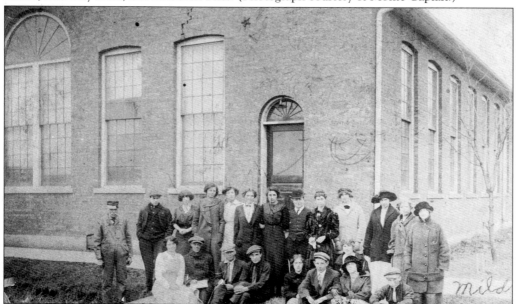

THE SILK MILL, WAVERLY. A 1914 directory lists the Waverly Silk Ribbon Company, C.R. Bean, manager, at 529–31 Broad Street. It is probable that this picture, identified only as "Silk Mill, Waverly. Fall 1914" shows the employees of that company. Norman Yontz is listed as the third person from the right in the front. (Photograph courtesy of Don Merrill.)

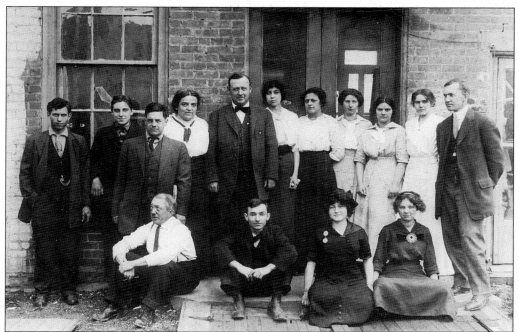

THE LEGAL PUBLISHING COMPANY, ATHENS. This business was on Elmira Street in Athens. Employees were, from left to right: (seated) unknown, Leslie Chandler, ? Whitley, and ? Bushnell; (standing) unknown, unknown, John Mullen, ? Baker, Fred Smith (proprietor), Leslie Hampton, Stella Flickenger, Lilian Palmer, Agnes Schoonover, Mildred Rider, and Hoyt Hager.

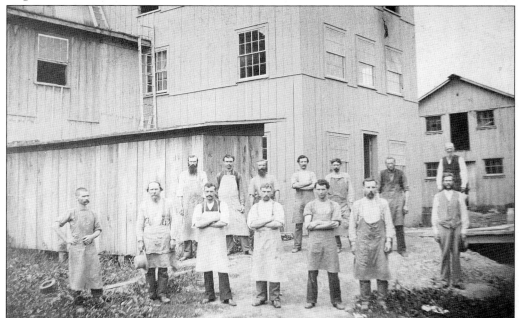

THE ATHENS FURNITURE COMPANY. The furniture company was located at the corner of Pennsylvania and Wheelock Avenues.

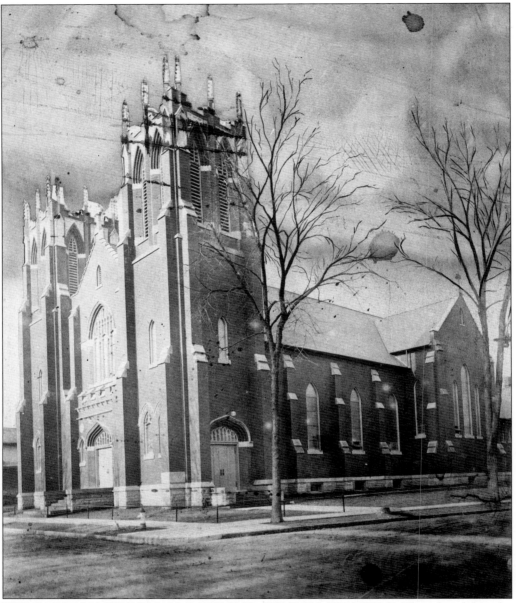

THE SAINT JAMES ROMAN CATHOLIC CHURCH, WAVERLY. This church on the corner of Chemung and Clark Streets was dedicated in 1913. (Photograph courtesy of Henry Farley.)

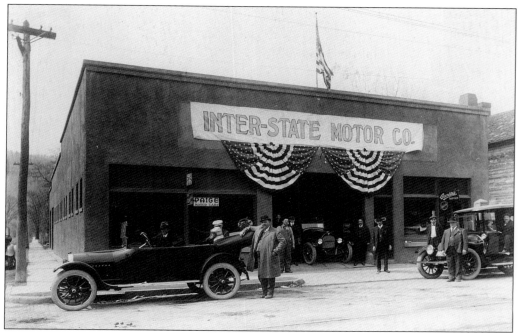

THE INTERSTATE MOTOR COMPANY, ATHENS. A 1917 advertisement featuring this picture reads: "The best equipped modern garage in the southern tier—Strictly fire proof . . . Every car guaranteed as represented when sold. Our repair department is equipped with the most up to date machinery and our mechanics are the best that money can procure."

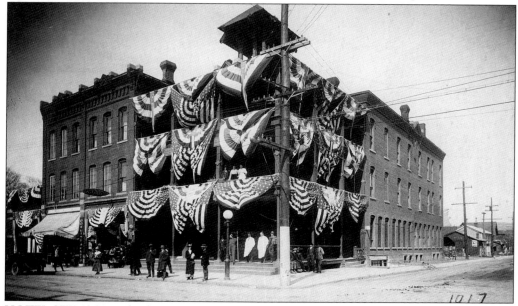

HOTEL STIMSON. This hotel stood at the corner of South Main and Susquehanna Streets in Athens. It is gone, but to the left is a building that still stands. It is difficult to think of it as a bowling alley, but that is what the sign says. Down Susquehanna Street it is possible to see the "American House" (see p. 30).

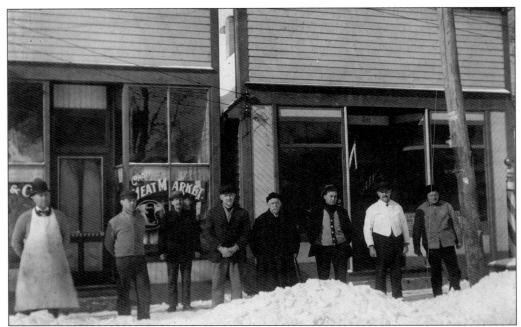

THE GROCERY AT 424 SOUTH KEYSTONE, SAYRE. These folks are standing in front of Frank T. Warburton's, where he sold groceries, dry goods, meats, hardware, chicken and screen wire, wash boilers and tubs, garden tools, hosiery, tobacco, confectionery, seeds, and Dexter Washing Machines.

ARMISTICE DAY, 1918. The inscription on the reverse of this photograph read:s "Armistice day, November 11th, 1918. Every one celebrating." The ladies are standing in front of a house on Paine Street in Athens.

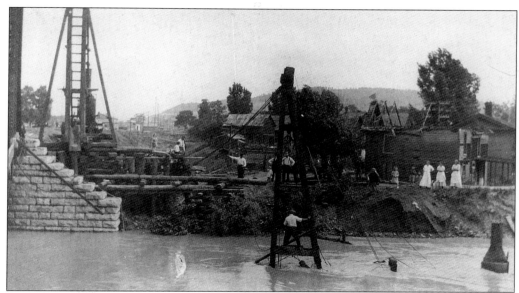

BUILDING THE RAILROAD BRIDGE. The Chemung River railroad bridge was built early in the twentieth century. There are no longer houses as close, but the bridge is still there and in use.

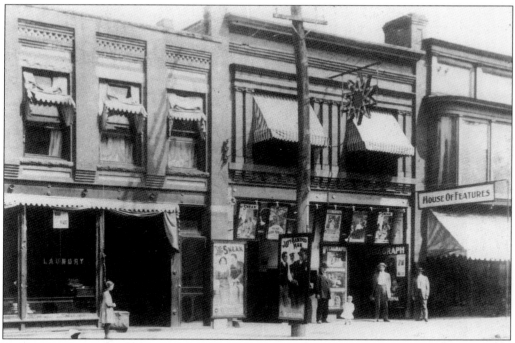

THE STAR THEATER. Between 1910 and 1915 233 Desmond Street, Sayre, housed the Valley's first theater. The proprietor, John R. Kasper, and his daughter Helen (the small girl in the white dress) are among the people standing in front. Mr. Kasper later turned the building into a Ford dealership. Now it is the home of Wolf Furniture and the *Daily Review*. (Photograph courtesy of Helen Kasper.)

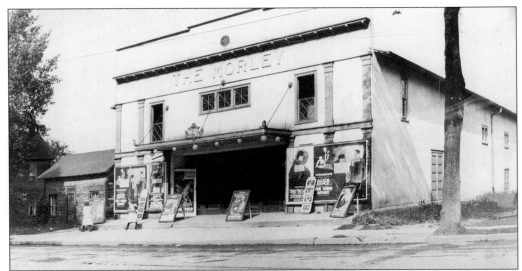

THE MORLEY. This theater in Athens once stood at 217 South Main Street, now the location of the Northern Central Bank. Long-forgotten movies are advertised on the posters attached to the front of the building and propped on the walk out front.

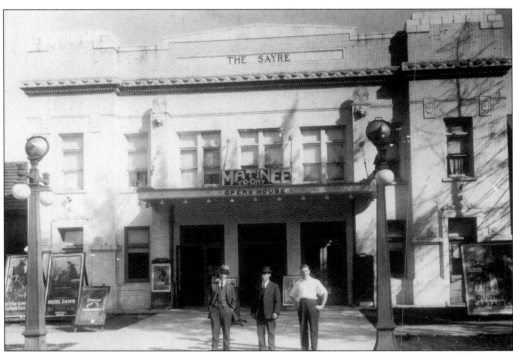

THE SAYRE THEATER, 1918. Owners Walter and R.W. Merrill stand along with operator Glen Winslow in front of the opera house on South Elmer Avenue. It is now the only place in the Valley to go out to the movies. (Photograph courtesy of Sayre Theater.)

Five
The 1920s and 1930s

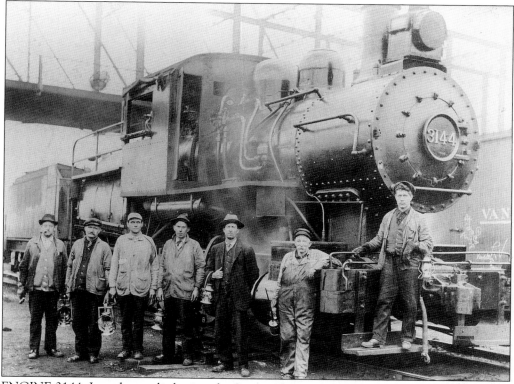

ENGINE 3144. It took very little time for Sayre to become an important railroad center. The Lehigh Valley Railroad focused much of its activity here because of its central location. A car shop, a repair shop, a blacksmith shop, a roundhouse, a paint shop, a cabinet shop, a machine shop, and a locomotive shop were located here. In the first quarter of the twentieth century, it became one of the largest locomotive shops in the world. This engine was built in Sayre in March 1913. The men in the picture are Harry Gates, Bill Swartwood, Berr Covey, J.R. Bermet (?), Pat Trainor, Mr. Stevens, and Bob Ramey.

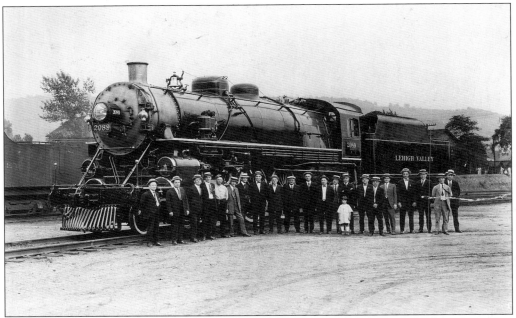

LEHIGH VALLEY ENGINE 2089. After 1926 new engines were no longer built in Sayre, but the shops remained busy reconditioning locomotives. This one was built in Sayre in June of 1925 and returned to be streamlined in 1939.

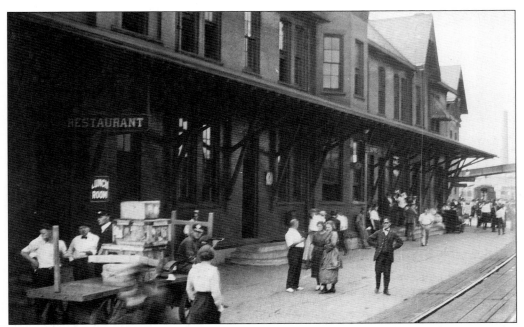

THE SAYRE LEHIGH VALLEY STATION. A busy Sayre station is shown in this photograph, apparently taken from a train window. Although most of the buildings associated with the railroad have been torn down, this one remains in good condition.

BEGINNING THE CONSTRUCTION OF THE NEW HIGH SCHOOL, SAYRE (1928). The last class to graduate from the old Sayre High School at the corner of West Lockhart and North Wilbur was the Class of 1928. The new high school was built down the road. It was completed in 1929.

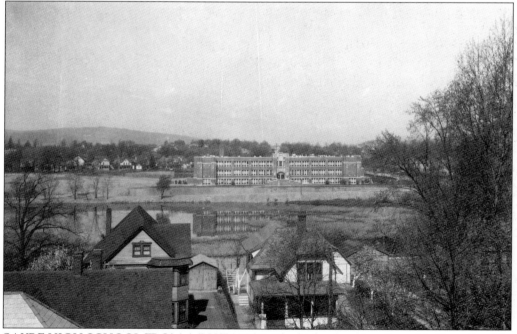

SAYRE HIGH SCHOOL FROM A DISTANCE. The high school is reflected in Sayre Pond in this picture taken shortly after its completion. (Photograph courtesy of Henry Farley.)

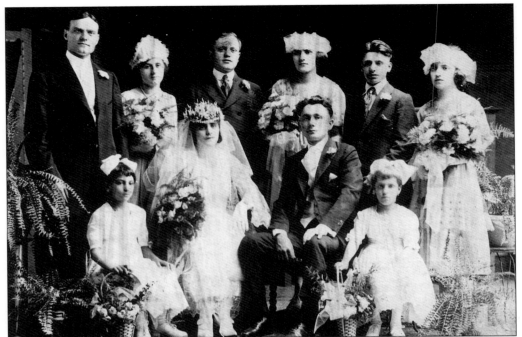

A JUNE WEDDING. On June 21, 1921, Carmella DiSisti married Frank Smith. The couple made their home in Sayre. Shown in this photograph are: Angelo Sisto, Mary Gaul Sisto, Peter V. Cacchione, Rose Dabbieri Erardi, Frank DiSisti, Lena Cacchione, Carmella DiSisti Smith, Frank Smith, Anna Dabbieri, and Molly Cacchione. (Photograph courtesy of Henry Farley.)

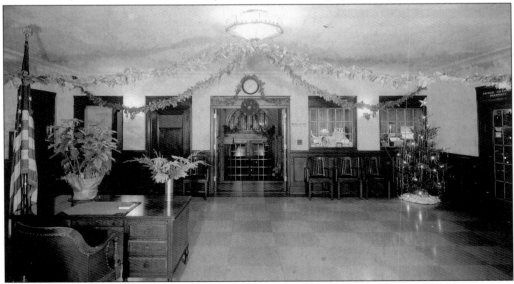

THE ROBERT PACKER HOSPITAL. The lobby of the hospital is dressed for Christmas in this 1928 photograph. This space in the Bird Sumner Building has been modernized and is now not recognizable from this picture. The marble plaque in the stairway straight ahead, seen sideways to the right of the glass doors, is virtually all that remains. (Photograph courtesy of Henry Farley.)

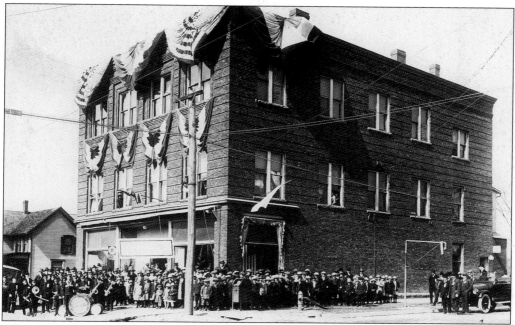

THE ODD FELLOWS BUILDING, ATHENS. The Independent Order of Odd Fellows held their Central District reunion in Athens and Sayre in 1917. Activities included parades, addresses, and concerts. This was their Athens headquarters, which has changed very little since this photograph was taken. It is located at the corner of Pine and North Main Streets.

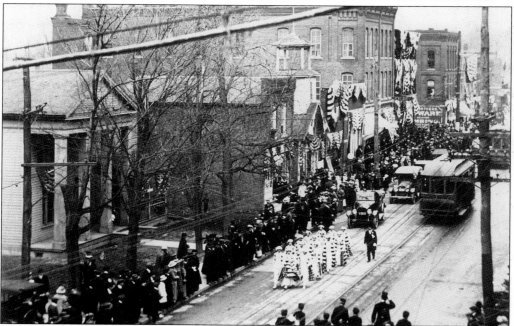

MAIN STREET, ATHENS, c. 1920. This parade is shown moving north on Main Street. The buildings seen to the far left of the image are no longer there. This area is the current location of the Athens Post Office.

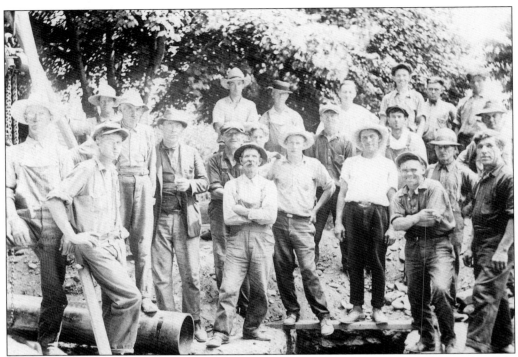

INSTALLING THE WATER MAIN IN WAVERLY. (Photograph courtesy of Don Merrill.)

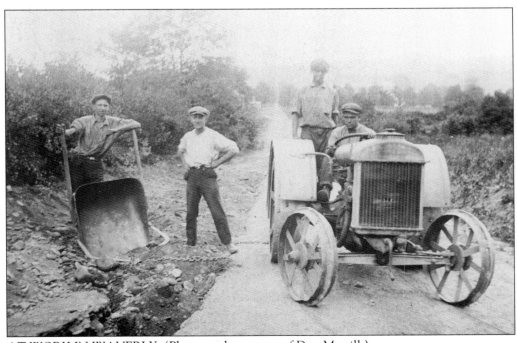

AT WORK IN WAVERLY. (Photograph courtesy of Don Merrill.)

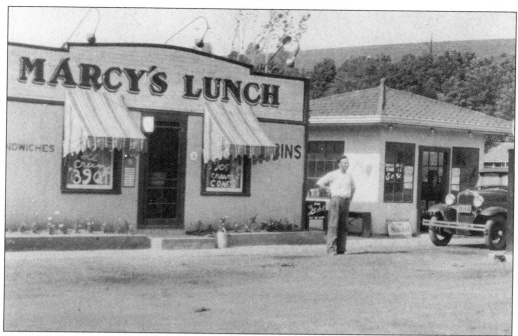

MARCY'S LUNCH, WAVERLY. This eating spot stood on Route 17. (Photograph courtesy of Don Merrill.)

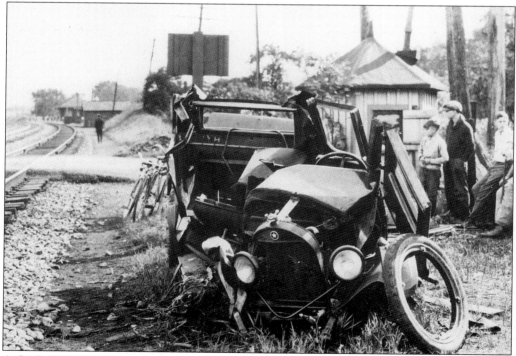

A CAR WRECK. This collision took place at the East Waverly highway crossing. (Photograph courtesy of Don Merrill.)

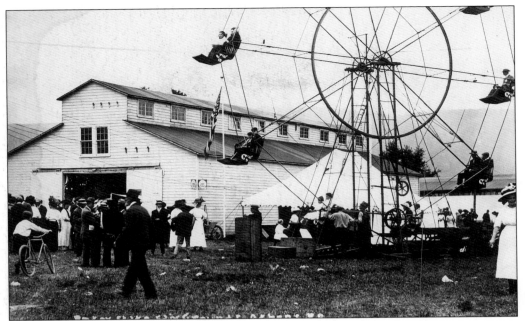

THE INTERSTATE FAIRGROUNDS. The fair was in East Athens. Spectators came to see horse races and exhibits of agricultural skills and crafts and to enjoy the midway rides. In 1909, a biplane was the big attraction. A Waverly newspaper account states that the crowd became unruly when wind prevented the scheduled flights. One spectator remarked: ". . . Airships are in their infancy but mighty hard to raise." (Photograph courtesy of Henry Farley.)

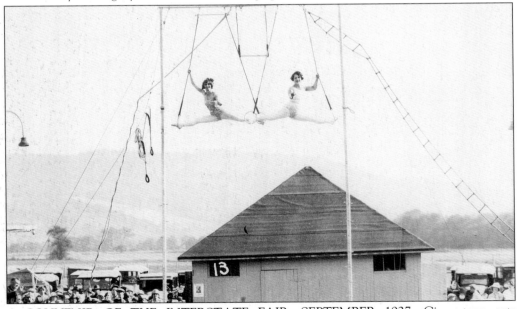

A SOUVENIR OF THE INTERSTATE FAIR, SEPTEMBER 1927. Circus-type acts performed at the fair, including Ouina Meers, "One of the cleverest, most finished and remarkable lady riders before the public," and Danny Ryan's Joy Riding Automobile, "The Greatest Comedy Act Ever Shown . . . A Laugh Every Time the Wheels Go Round."

LADIES IN COLONIAL GARB. A patriotic occasion probably prompted this display of costumes on the front porch of a house on south Main Street, Athens.

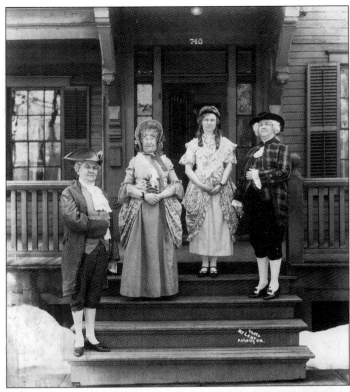

FLOWER GIRLS AT A WOMANLESS WEDDING. Who knows what prompted this display of . . . costumes? Both this photograph and the one above it come from the files of the prolific Valley photographer Eugene Lent, who had offices in Waverly, Sayre, and Athens from the 1920s through the 1950s.

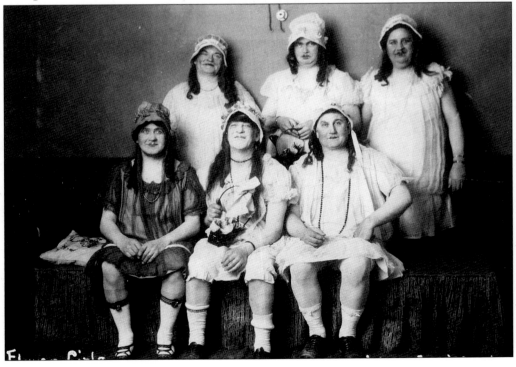

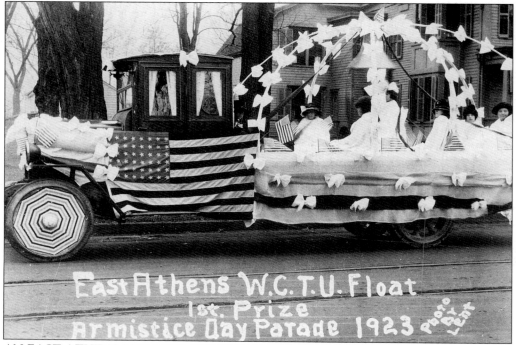

East Athens W.C.T.U. Float
1st. Prize
Armistice Day Parade 1923 PHOTO BILY KENT

AN EAST ATHENS WOMEN'S CHRISTIAN TEMPERANCE UNION FLOAT. This float took first prize in the Armistice Day parade in 1923. It is shown here on South Main Street in front of the same house in the photograph on the previous page.

LOOKING NORTH ON SOUTH MAIN, 1936. Those tiny hemlocks have grown into large trees that create a canopy over the walk. The Hunsiker house is on the left with the library-museum building beyond it.

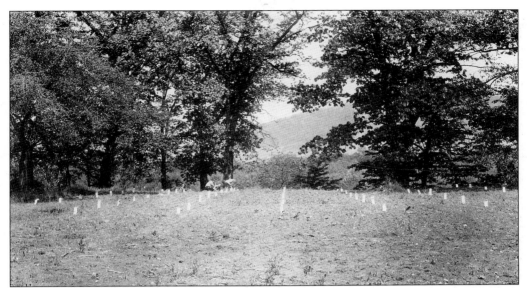

AN ARCHAEOLOGICAL EXCAVATION ON SOUTH MAIN STREET, ATHENS, 1933.
This whole area was occupied by Native Americans repeatedly over the centuries and evidence
of the settlements exists under the ground. Sometimes it was discovered accidentally during
construction projects or by farmers working their fields, and other times archaeological digs
uncovered it.

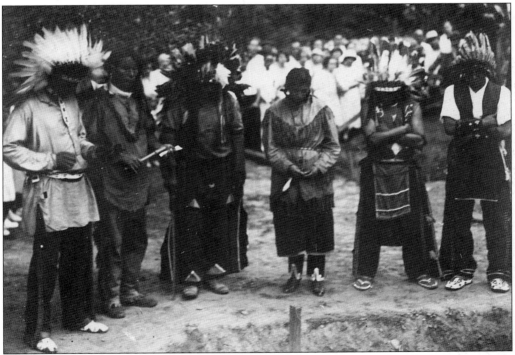

A REBURIAL CEREMONY (1933). After the completion of one archaeological excavation
that uncovered human remains, Native American representatives conducted a ceremony in
which the remains were reburied.

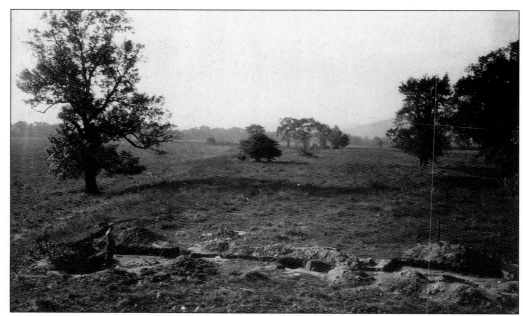

A GENERAL VIEW OF THE SPANISH HILL SITE (1933). Excavations of Spanish Hill in 1916 by the Susquehanna River Expedition, in 1931 by J.B. Griffin for the Tioga Point Museum, and in 1933 by Ellsworth C. Cowles failed to uncover much.

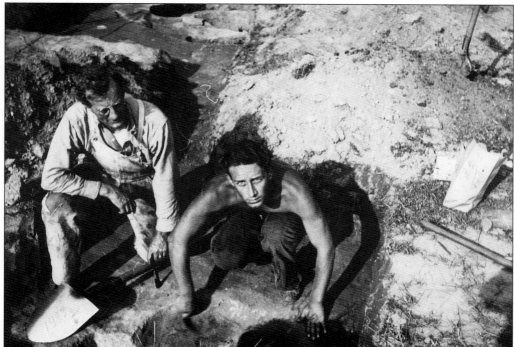

EXCAVATIONS AT SPANISH HILL. M. Louis Gore (left) and Dale Woodruff worked on the 1933 Spanish Hill excavation. Mr. Gore was the photographer who took many of the photographs of old houses that appear earlier in this book.

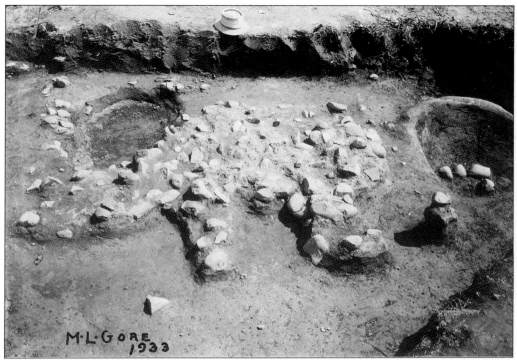

AN EFFIGY HEARTH DISCOVERED. In 1933, at a site near Spanish Hill, Ellsworth Cowles uncovered this hearth, the shape of which may represent a mastodon. The archaeologists theorized that it was used for ritual purposes, since it did not appear to have been used for cooking. It was prehistoric, but was never satisfactorily dated.

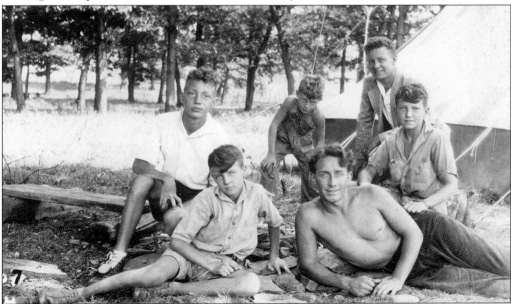

SIX LADS ON A BREAK. The excavations employed local diggers who took a moment to pose for this shot. Dale Woodruff is on the right. The others are unknown.

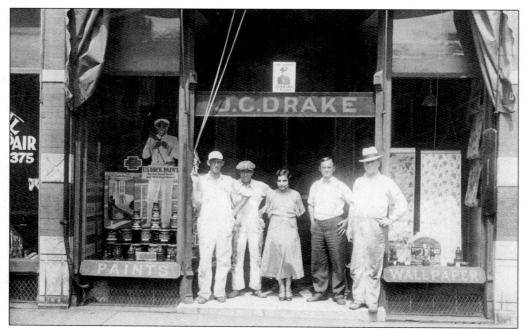

JOHN C. DRAKE, PAINTER. A 1931 directory puts this business at 377 Broad Street in Waverly. Above the door is an election poster that reads "For Sheriff, Jenkins of Waverly." (Photograph courtesy of Don Merrill.)

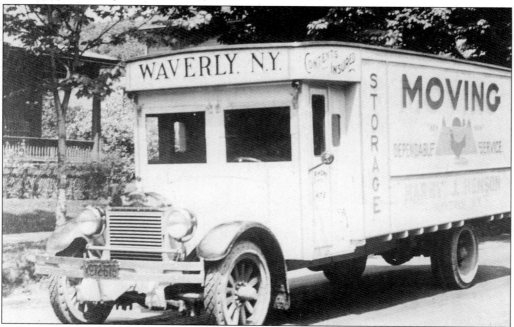

HARRY J. HENSON MOVING. In 1928 Mr. Henson advertised piano moving and hoisting as a specialty. His office was at 441 Waverly Street in Waverly. The logo on the side of the truck is a play on his name, a hen standing before the rising sun. (Photograph courtesy of Don Merrill.)

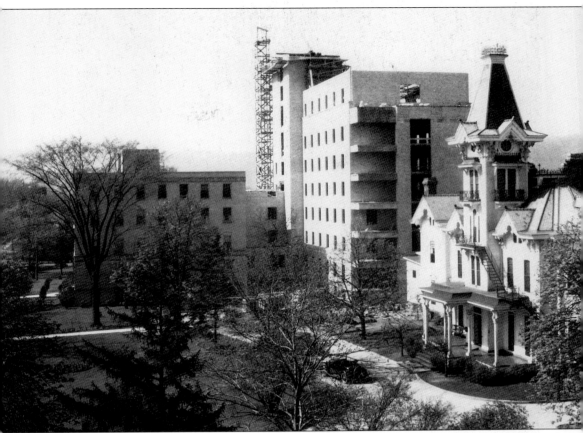

BUILDING THE NEW HOSPITAL AFTER THE FIRE. By 1933, the Robert Packer Hospital had grown to 275 beds. Much of the growth was due to the vision of Doctor Donald Guthrie, surgeon in chief of the hospital and founder of the multi-specialty Guthrie Clinic, which attracted patients from a wide area. In 1933 a fire struck the hospital, causing 1.5 million dollars worth of damage. Rebuilding plans began immediately, with the new hospital opening in December 1934. The Packer mansion was no longer the hospital, but was used by the hospital for a number of different functions. The grand house was finally demolished in 1960 to make way for more expansion. (Photograph courtesy of Henry Farley.)

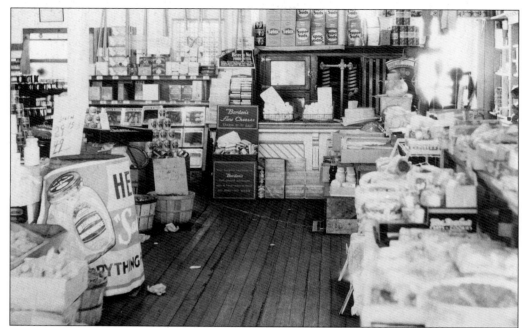

SAM REBEK'S STORE AT 340 BROAD STREET, WAVERLY. The interior of Mr. Rebek's store on June 28, 1934, shows what a typical market of the time stocked. Some brands are familiar, others are long gone, such as Selax and Super Suds. (Photograph courtesy of Don Merrill.)

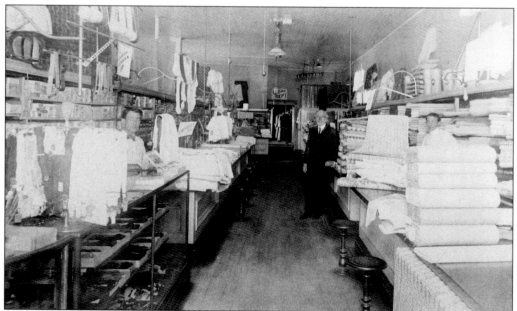

KNAPPS DEPARTMENT STORE, WAVERLY. The book *Waverly Centennial*, published in 1954, has an advertisement for Knapp's Department Store that mentions it was "Established 1874 . . . 80 years old this year." This picture shows "Dad Greer" and two other men standing among the dry goods some time in the 1930s. (Photograph courtesy of Don Merrill.)

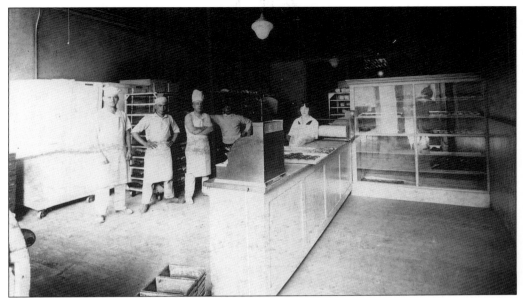

PARK BAKERY, DESMOND STREET, SAYRE. The people in this photograph are, from left to right: Frederick Grussman, Fred Cacchione, Dean Ramsey, Anthony Nocchi, and Lena Cacchione. (Photograph courtesy of Henry Farley.)

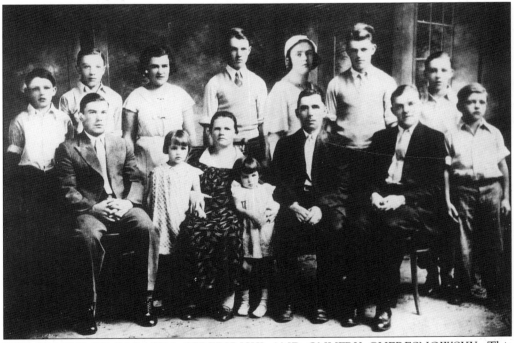

THE FAMILY OF PARASKA SEREDYNSKI AND ONUFRY CHERESNOWSKY. This family photograph was taken around 1934. Pictured are, from left to right: (in front) Nicholas, Dorothy Patterson, Paraska, Ginger Frantz, Onufry, and Peter; (in back) Theodore, Mathew, Anna Geffert George, Mary Shoemaker, Andrew, Leo, and Walter. (Photograph courtesy of Henry Farley.)

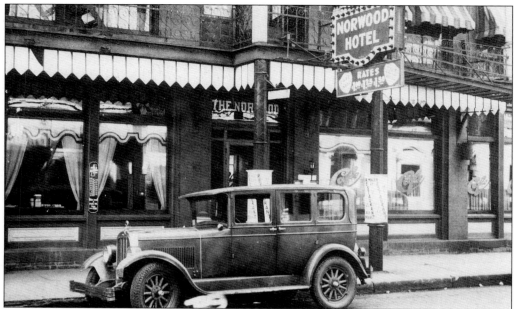

THE NORWOOD HOTEL, WAVERLY. In 1893 a Mr. Fenell built the Norwood. A turn-of-the-century advertising booklet states that it was noted for its "high class cuisine." In 1936 the room rates at the Norwood were only $1, $1.25, and $1.50. It did not cost extra to park the car and the room came with hot and cold water. The hotel was at 427 Fulton Street in Waverly. (Photograph Courtesy of Don Merrill.)

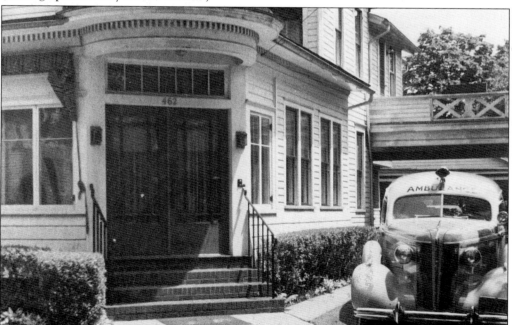

THE L.S. GEER FUNERAL HOME. Lester Geer provided privately owned ambulance service to the Valley for twenty-five years, in addition to his business as an undertaker. (Photograph courtesy of Don Merrill.)

THE FIRE STATION, EAST
WAVERLY. (Photograph courtesy of
Don Merrill.)

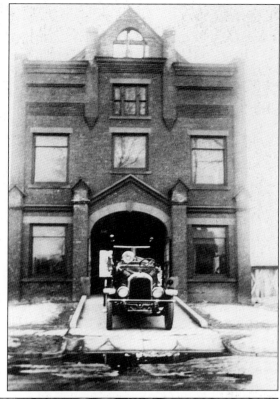

A NEW 1938 QUAD FIRE TRUCK.
The fire department stands proudly by
their shiny new 39.5-foot-long truck.
The men are, from left to right: William
Laux (captain, fire police), Lawrence
Draper (dormitory fireman), Dominic
Piarulli (dormitory fireman), Joseph
Pritchard (dormitory fireman), Lloyd
Rifenberg (dormitory fireman), Earl
Davidson (first assistant fire chief), and
Albert Frank (fire chief). (Photograph
courtesy of Henry Farley.)

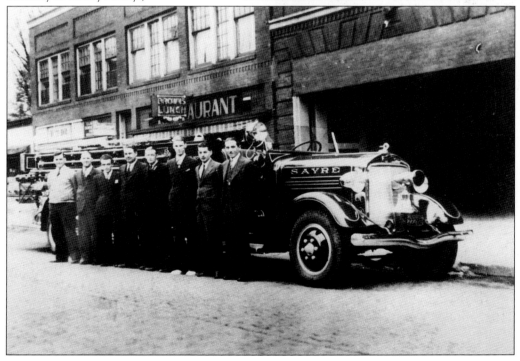

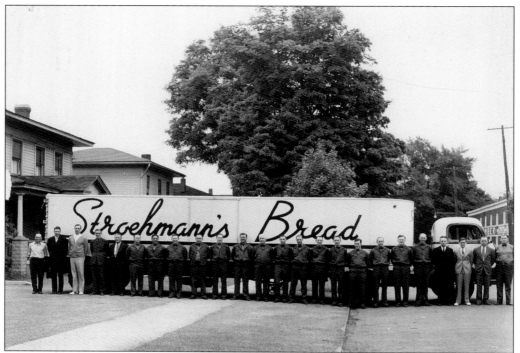

THE STROEHMANN BREAD COMPANY, WAVERLY. This company has been in the Valley for a long time. In this June 1939 photograph, the sales office and garage force are pictured. (Photograph courtesy of Henry Farley.)

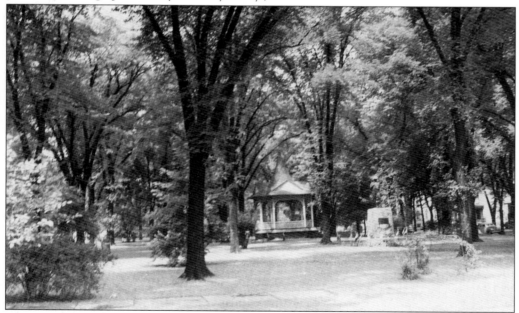

HOWARD ELMER PARK. The shade trees and bandstand have always made this square in Sayre a popular place. The elm trees in this photograph from the 1930s are gone, but they have been replaced by other trees. (Photograph courtesy of Mollie Caplan.)

Six
The 1940s
to the Present

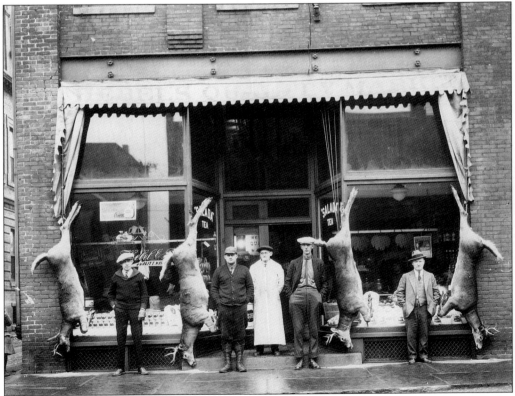

HEBEL'S QUALITY MARKET. This store was located at 104 South Elmer Avenue. In this picture, Tommy Jordan is on the right and "Pee wee" Daniels is on the left.

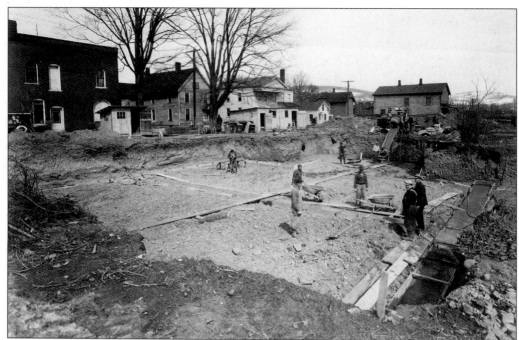

THE NEW ATHENS POST OFFICE, MARCH 26, 1940. The pictures on these two pages were taken by M. Louis Gore, and show the post office in Athens under construction. From the southwest corner, looking northeast, Public Street can be seen. (Photograph courtesy of the Athens Post Office.)

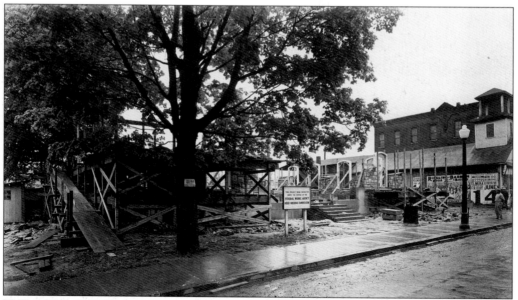

THE POST OFFICE, MAY 27, 1940. The foundation is complete and the stone building is beginning to rise. Posters advertising the Ringling Brothers and Barnum and Baily Circus are visible on the building to the left (no longer standing). (Photograph courtesy of the Athens Post Office.)

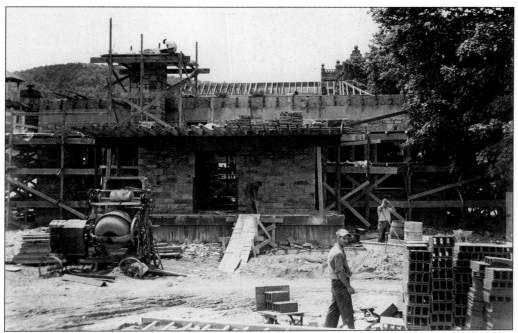

THE POST OFFICE, JUNE 27, 1940. From the back, the stonework is almost complete. Some of the larger buildings on South Main can be seen beyond the construction. (Photograph courtesy of the Athens Post Office.)

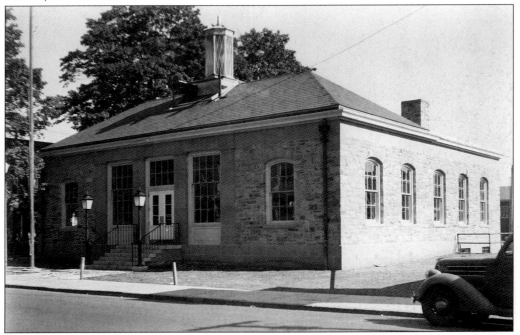

FINISHED, SEPTEMBER 26, 1940. This is the final product with just a small amount of work left to be done on the top. Except for the landscaping, the appearance of the post office has not changed since it was built fifty-six years ago. (Photograph courtesy of the Athens Post Office.)

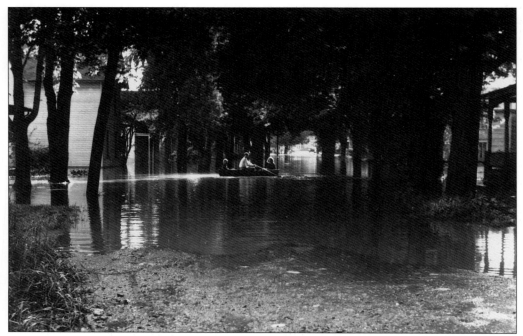

A FLOOD, MAY 28, 1946. This time the boating is on Bridge Street in Athens.

THE CORNER OF WEST PACKER AND ELMER. On this day, c. 1937, Joe Glaser sat waiting for a parade that never came. The house across the street is where the Dandy Mini-Mart now stands. Next to it was a tiny gas station. (Photograph courtesy of Mollie Caplan.)

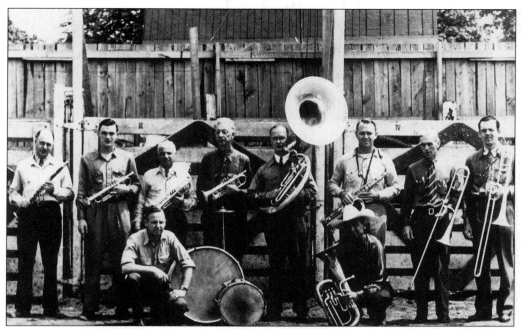

COLONEL JIM ESKEW'S RODEO BAND. The Jim Eskew Rodeo headquarters were on a large farm a few miles north of Waverly. This photograph shows the band in 1946. From left to right: are: (kneeling) Edward Ashworth and Alton Lay; (standing) Dante Coccagnia, Richard Swetland, E.M. Alliger, Nick Fiore, Leon Hawthorne, Ralph Bartlett, Fred Ennis, and S. Larson.

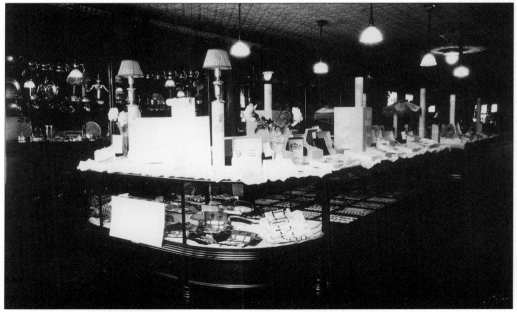

IKE SAMUEL'S JEWELERS. This shop was at 111 West Lockhart in Sayre. Mr. Samuel stocked jewelry, silver, fine stationery, and the latest in RCA Victrolas. (Photograph courtesy of Mollie Caplan.)

THE ATHENS SILK MILLS. This company was in business on Pine Street and many in the Valley remember working here. After the silk mills went out of business the building was used for other purposes, including a wreath factory. It burned down in the early 1990s.

THE INTERIOR OF THE SILK MILLS. The zig-zag roof line typical of industrial architecture allowed sunlight into the work space. During World War II, workers made bandages, slings, and parachutes here.

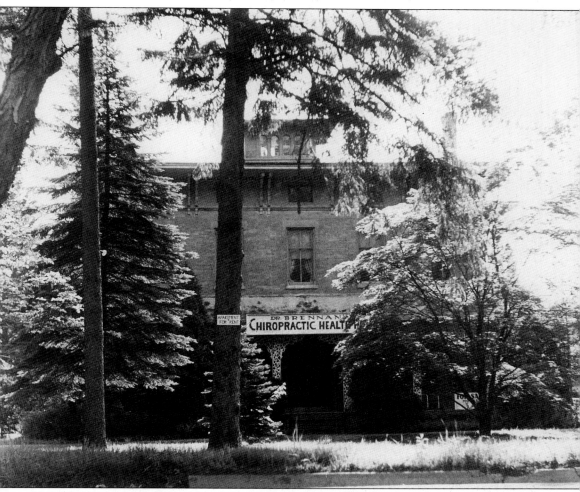

THE BRENNAN HOUSE. After C.F. Welles' family sold the house in Athens (see p. 33), it was the office of a chiropractor, Dr. Brennan. It is once again a family home and has been restored to fine condition.

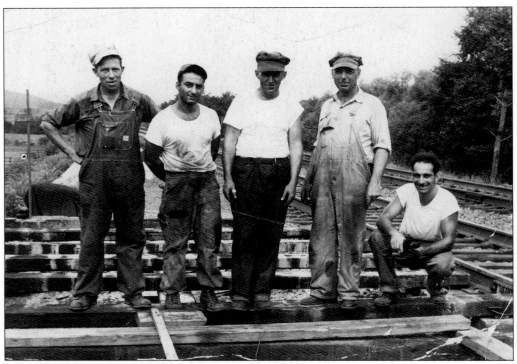

RAIL WORKERS, SOUTH WAVERLY, *c.* 1938. These men are working on the Delaware, Lackawanna and Western Railroad tracks, which were removed when Route 17 was put through. Anthony Condame is second from the left, Charlie Smith is second from the right, and Michael Condame is on the right. (Photograph courtesy of Joann Homan.)

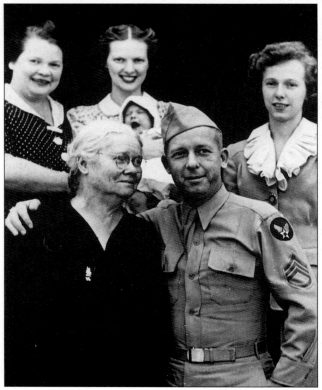

THE J. FRANCIS CAIN AND FAMILY. From left to right are: (front row) Ellen Coveway Cain and J. Francis Cain; (back row) Marie Cain Reynolds, Veronica Reynolds, and Vivian Reynolds (Wolcott). J. Francis Cain participated in the infamous Bataan Death March during World War II. (Photograph courtesy of Henry Farley.)

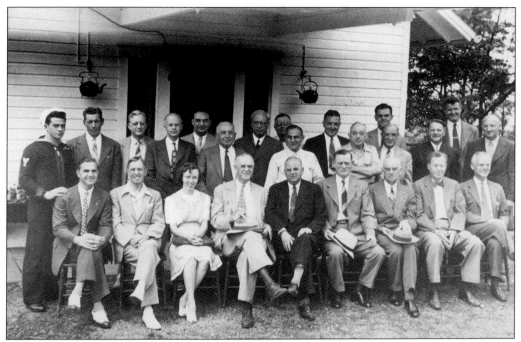

THE WAVERLY ROTARY CLUB IN JULY 1945. The members pose with their guest, Boatswain Mate 2/c Raymond L. Boyle. (Photograph courtesy of don Merrill.)

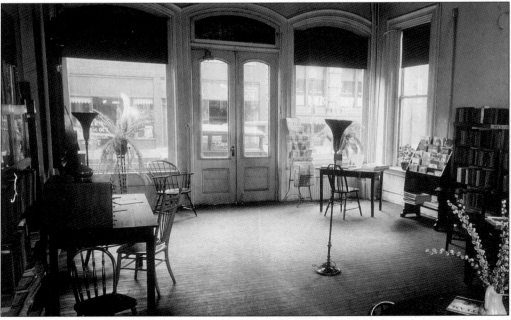

THE INTERIOR OF THE OLD WAVERLY LIBRARY. The library stood at 434 Fulton Street. It has been replaced by a modern building around the corner on Elizabeth Street. (Photograph courtesy of the Waverly Free Library.)

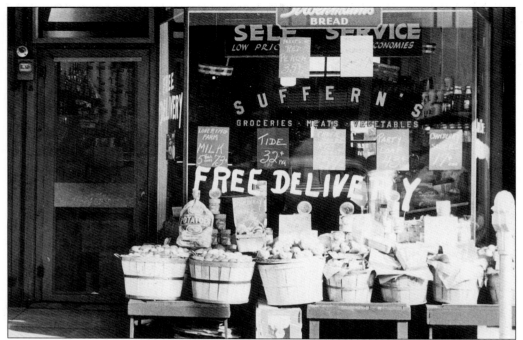

SUFFERN'S GROCERIES, MEATS AND VEGETABLES AT 323 BROAD STREET, WAVERLY. Chuck roast and rib roast at 59¢ a pound and five tall cans of milk for 73¢ were among the bargains offered here. (Photograph courtesy of Don Merrill.)

GLASER'S REXALL. Sidney Glaser reviews records at his drug store at 121 West Packer Avenue in Sayre. This picture was taken around 1950. (Photograph courtesy of Mollie Caplan.)

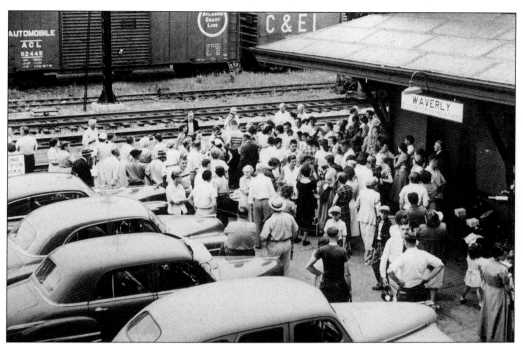

THE WAVERLY STATION FOR SAYRE AND ATHENS. Until recently, Valley residents could still catch a train to get from town to town. (Photograph courtesy of Don Merrill.)

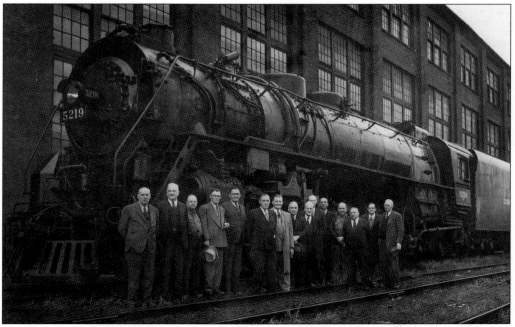

ENGINE 5219 ON DECEMBER 10, 1952. This engine, seen in the repair yard, was commissioned in 1943. It was probably about to be scrapped. The men in the photograph are: A. Hickey, E. Fohl, S. Kinner, W. Varner, J. Childs, J. Maloney, C. Fuller, A. Birney, H. Morley, E. Peterson, G. Voest, P. Roney, H. Ritz, J. Schoonover, and W. Hyland.

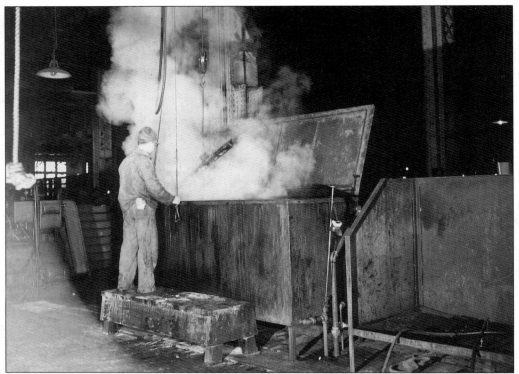

THE DIESEL SHOP, LVRR. These two views of the diesel shop show men working on parts for the locomotives that came out of Sayre. The size of the equipment dwarfs the workers.

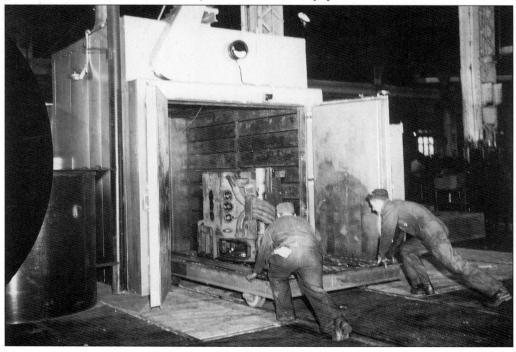

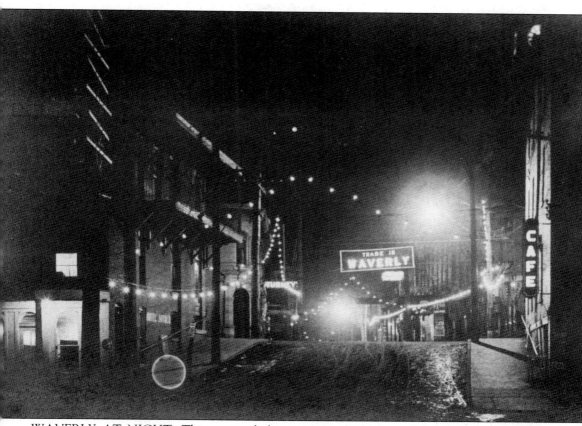

WAVERLY AT NIGHT. This postcard shows a view looking up Fulton Street from the railroad tracks toward town. (Photograph courtesy of Don Merrill.)

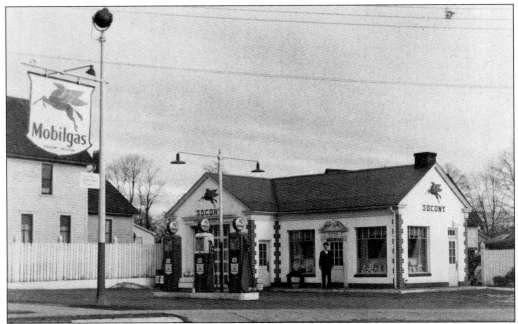

THE BOB DAVIS SERVICE STATION, WAVERLY. The old-style pumps and the fellow neatly dressed in a cap and bow tie waiting to pump gas date this picture to some time in the fuzzy past. This station was on the corner of Chemung and Elmira Streets. (Photograph courtesy of Don Merrill.)

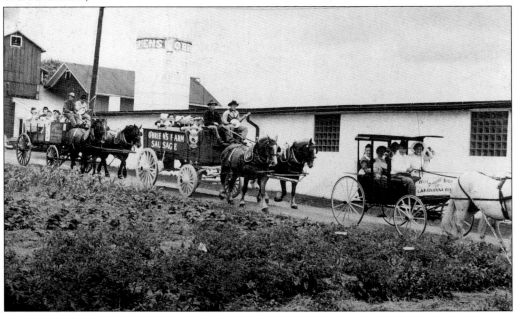

O'BRIEN'S, WAVERLY. An area landmark, the O'Brien's sign can be seen from a great distance. The occasion for this costume parade is unknown, but the participants are passing in front of the O'Brien's farm in a wagon advertising their sausage. (Photograph courtesy of Don Merrill.)

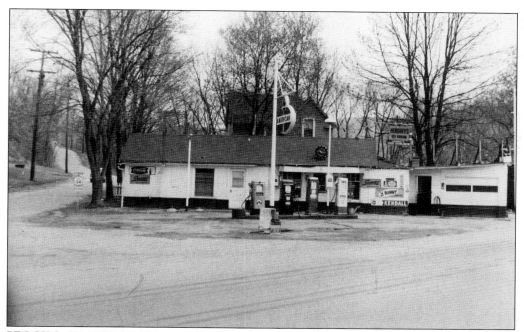

PEGGY'S, WAVERLY. This used to stand on Route 17C. (Photograph courtesy of Don Merrill.)

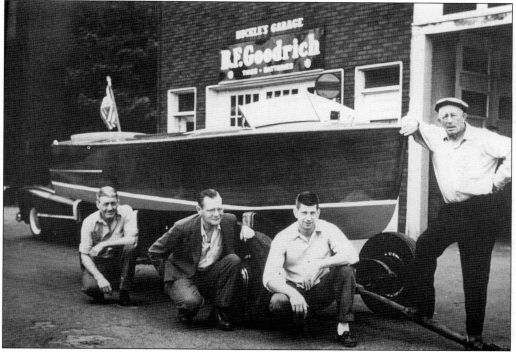

HUCKLE'S GARAGE, WAVERLY, JUNE 1950. Harold Jenkins, Byron Winters Jr., Delbert Huckle, and Lee Starr pose by a Chris Craft boat in front of this Elizabeth Street garage. (Photograph courtesy of Don Merrill.)

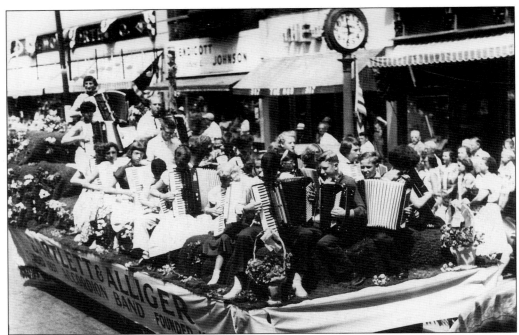

THE BARTLETT-ALLIGER ACCORDION BAND. The band took second prize in the Waverly Centennial Celebration Parade in 1954 for this float. Ralph Bartlett organized the band in 1937 and was joined in 1945 by E.M. Alliger.

A TRAIN WRECK, WAVERLY. In 1970 this Erie-Lackawanna train accident occurred in Waverly. (Photograph courtesy of Don Merrill.)

THE ATHENS LEHIGH VALLEY STATION. This picture was taken shortly before the station was torn down in the 1980s. It used to stand just south of the Ingersoll-Rand plant.

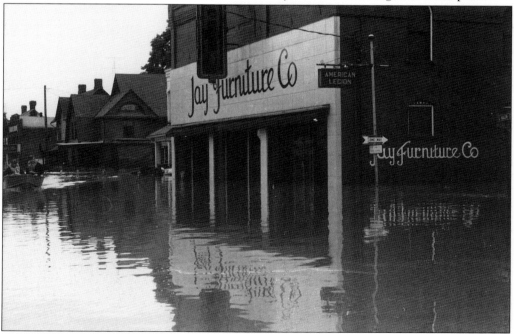

THE FLOOD OF 1972. This is the flood that everyone remembers. Hurricane Agnes caused the inundation of much of the Northeast that year, particularly along the Susquehanna River. People tell stories of big fish in their front yards and are still cleaning river mud out of unlikely places.

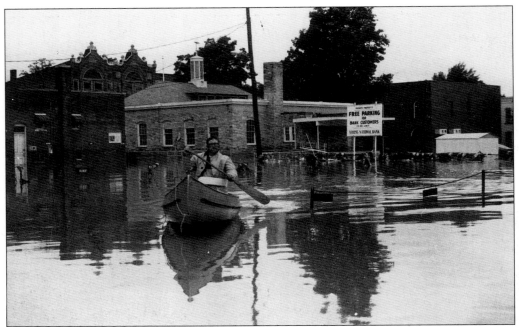

THE FLOOD OF 1972. Athens bore the brunt of the flooding this time, after several dikes gave way. Water reached second-story levels in the downtown area and left several inches of mud when it receded. Damage to the area was widespread, and for several days the Valley was virtually cut off from the outside world.

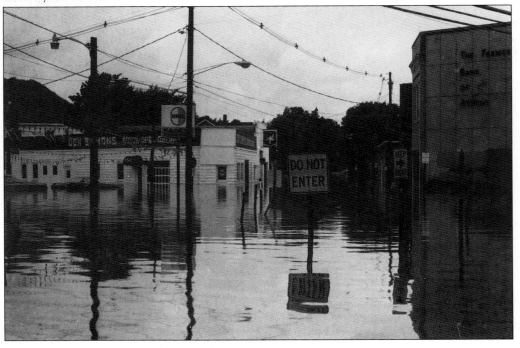

THE LOCKHART STREET PEDESTRIAN BRIDGE. Many local people have fond memories of this bridge, which spanned the Sayre yards until recently.

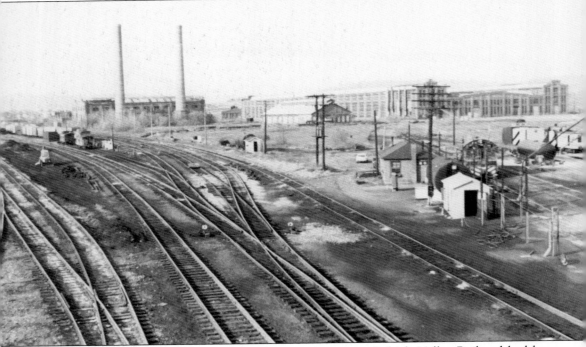

THE EAST END, SAYRE YARDS. The once-prosperous Lehigh Valley Railroad had been struggling for years, and had been absorbed by other rail lines, when it finally went out of business in 1976. For a time the buildings in this photograph remained, but they are now also part of the past.